WHEN YOU ARE LOST

What foraging maxims can teach us about survival

JOY COLANGELO

WHEN YOU ARE LOST:
What foraging maxims can teach us about survival

Copyright : Joy Colangelo, 2020
All illustrations and fabric collage : Joy Colangelo

Joy Colangelo @ JoyPress
133 18th Street
Pacific Grove, CA 93950
www.joycolangelo.com
joy.colanagelo@gmail.com

Library of Congress Control Number: 2020918152
ISBN : 978-1-7357802-0-7

Cover fabric collage by author: joy colangelo
Printed in the United States of America

INTRODUCTION
IT'S NOT ABOUT WHO GETS LOST, IT'S WHO GETS FOUND

Even though more than 2,000 people a year get lost in the woods, you are unlikely to ever get into a life or death, time-crunching, heart-wrenching survival situation. So you might wonder how a guidebook like this could possibly be useful. Well, put simply, because sometimes we spend our days being bewildered, confused about where we are going and from which direction we came. Some days we just feel lost. Though it happens to everyone, we know some of us navigate that feeling better than others.

What if we could navigate life's challenges, both emotional and physical, by learning what survivors know? Survivors of life and death situations make the decision to be found wherever they find themselves. They know that when they find themselves lost, all is not lost. They are able to navigate "critical incidents," be nimble during the unexpected, and confront an experience that threatens their basic assumptions about life and their ability to survive through it. Rescuers tell us that the Rambo type rarely survives; that capable and experienced adventurers are found dead with their equipment unused and many with an encyclopedic knowledge of their passion, be it solo sailing, high peak climbing, or any high risk sport, make a critical, life-ending mistake that belies their experience. We know that survival is closer to an art rather than a science and most importantly, it's more about what is in your heart rather than what's in your head. Those who survive have lived a life wherein they do not imagine themselves as victims; they have built on previous injustices and with that

2

"building," their mental health has strengthened. Thus their attitude when threatened with extinction is positive. They have dug in before; they have fought before. They have jumped hoops, obstacles, and enemies before, culminating in an advantage. That advantage? Everything you have lived through has been practice for handling the next crisis. And the next. It's not about being lost, it's who is lost. Medical research breakthroughs come sometimes in studying not who gets sick,

but who isn't. With cancer, it all shifted when scientists realized it wasn't about who gets cancer, but who keeps theirs.

My wish is that this book assures your survival in the worst of situations be it the personal or professional betrayals that surprise us, the grief whose depth seems a relentless abyss, and the material losses that force us to start over and over. And sometimes, over yet again. While this guidebook assumes we are lost in the woods, it serves as a metaphor for the lost feeling we have, sometimes every evening in the comfort of our home, our resources well at hand, yet we find ourselves staring into a dark place. We'll dig into this predicament and get ourselves

out the otherside.

Knowing that most rescues occur when day hikers get disoriented or caught in bad weather, this handbook will assume you have no water with you, no extra clothes or camping gear, no tools and no ability to build fire. You don't

know the names of plants nor their medicinal properties. What we'll learn is that you are as equipped as anyone to survive.

I've worked in a hospital for over 2 decades and have taught a foraging class for years where I live in Central California. The class is called "how not to die." It is not called "how to live" because there are plenty of survival and foraging books that teach you the secrets of the forest. To benefit from them, they require an excellent memory, a near encyclopedic knowledge of botany and years of learned craftsmanship. This book and my class, focus on a few maxims, knowing that none of us (really, none) can remember the names of plants, their juvenile and adult presentations, the season in which they are useful and where they are likely to be found. Why muddle the brain with such details when it's an impossible task? Instead, my class convenes in a dirt parking pull out just behind the

community college in Monterey near a small pond. We don't hike, trek, climb, wade or even bend a knee. We look around and realize, "Most of this is food, most of it is shelter, and much of it is clothing." This one realization will calm the brain and so

begins the first *maxim: it's only a calm brain that will get you through a crisis.*

We have many trials in life and many times we feel lost, abandoned and directionless. We can feel just as lost in a concrete jungle as a wild one. But we navigate it as best we can, sometimes with the help of services or friends. Those "services" exist in the woods, we just don't know they do, or the instructions are too complicated to remember. This guidebook will reduce that remembering so that by the end, you'll navigate a successful path, getting from lost to found.

FOCUS ON NARROWING YOUR FOCUS

The Ring Theory, developed by a young mother enduring bone marrow transplant, can be used for when lost in the woods. Susan Silk figured out why some visitors' comments helped and some hurt, especially co-workers who said she was missed. She realized she was the center of a ring of people. She was the center because she was in immediate crisis. She was allowed to say anything to anyone in the outer rings. The next ring was her husband - only he could fathom the pain of a parent dying because he was the other parent. Thus he is the only person who can talk with her about that topic. His fears of a future without his wife were to be heard but heard only by the next ring out from him.You can only "complain out." You can't "dump in." In this case, that ring was his mother-in-law. She's the one he talks to about raising the children with her help. The rings of co-workers can only bemoan how hard work is to co-workers beyond their ring. This way, the center of the ring stays filtered of well-meaning but useless and exhausting problems, all enormously more trivial than her trials. This is so helpful in determining the meteoric thought intrusions in our brain whether we are having an uneventful day or the worst day of our lives. Some functions of the brain need to be turned off and tuned out while others need center stage. Some circles in the brain shouldn't have unrelenting and unfiltered access to the inner circle. This brain focusing will be critical when we

take our steps into terra incognita. This guidebook is going to pretend we are lost in the woods -- and it's going to get us out again. We are going to get found. I should say "or die trying" but let's see if we can avoid that. Otherwise, why write the book?

It is well known in medicine that illness shrinks the scope of conflicts to a size that can be tackled. In other words, you have less rings around you calling for your attention. You must focus on navigating the illness and the emotions that come with it, not expending expensive brain resources on trivial issues like buying a new jacket or testing a new recipe. Often, even in a dire illness, anxiety is lessened if not eliminated due to the very fact that you have one immediate problem. To highlight how expensive the brain is when it comes to energy, it's a good thought problem to figure out which sport consumes the most calories. An Olympic, gold medal swimmer will consume 5,000 calories a day while training but only 10 calories while racing as their metabolism has become so skilled and efficient, it should win the gold medal. Considering this athlete is in water (water sports kick in a survival mechanism wherein you store a layer of fat to insulate you from the cool water which is why elite swimmers don't look "cut" with muscle definition but in fact look a bit flabby), one would make a calculated guess that they are using the most calories. Or perhaps you know that one of the most physically fit athletes are the motocross racers, enduring vibration and impact while mastering a heavy motorcycle around tight curves. But nope. Or a professional cyclist who is competing in the only sport that requires several food handoffs to make it through one race. But it's not them either. Who uses the most calories? A master chess player has a need for 6,000 calories a day in a several day tournament with a possible loss of 1 pound a day. The brain uses sugar to function, has no storage capacity and during chess is making hundreds of thousands of calculations chewing up sugar as fast as it can. When Gary Kasparov was beaten by Deep Blue, a computer generated opponent, he stated that the computer

had only one thing to focus on which was available moves and strategies. He however was remembering that his father taught him the move he was considering or that the ivory chess pieces were from elephant tusks along with the fact that he was hearing background noises and conversations or was chilled and even, very hungry. The computer had none of this to contend with. In a way, the computer was also not spending calories defending its' ego, a very expensive and useless diversion. Many a lost soul has been found on the brink of death and yet admitted they had seen the rescue planes overhead and were near a clearing, or had even heard other hikers across a canyon, saw lights in a cabin and yet did not seek help. Why? They said they were too embarrassed so they kept walking. In a very real sense, they were found but remained lost to protect their ego. In fact, rescue teams know that it is more likely for a hiker to feel embarrassment before panic. The trouble is, embarrassment or the fear of failure can destroy you, and the price you pay keeps you from being successful. That's expensive indeed.

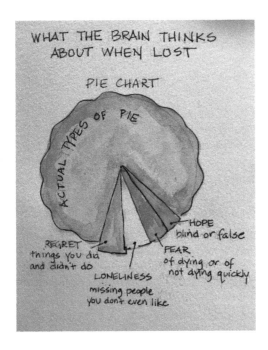

WHAT THE BRAIN THINKS
ABOUT WHEN LOST

PIE CHART

ACTUAL TYPES OF PIE

HOPE
blind or false

FEAR
of dying or of
not dying quickly

REGRET
things you did
and didn't do

LONELINESS
missing people
you don't even like

In a survival situation, we'll only survive with a calm brain, a brain working with serotonin and dopamine. Flight or flight is useful only for the most immediate danger - say a mountain lion threat - where we have two choices. We can fight or flee. That response requires stress hormones like cortisol and adrenaline. We either make ourselves look big and angry, as if we will win the fight, or we run. Chemicals shunt our blood to our leg muscles so we can run or kick, while stealing the blood from our hands and feet so if wounded, we don't bleed to death. It stops any resources to our intestinal tract so we don't waste energy on digesting food since we are about to be food ourselves and dumps the debris from our intestines so that we soil ourselves, making us both too smelly and slippery to catch. And then the body does another brilliant thing - it drains reason from our brain. Cortisol, testosterone and adrenaline are not reasonable chemicals. Survival mode is not the time for the brain to think, never mind stop to ponder it's options. We don't

have time to say to ourself, "I wonder if that's one of the trained mountain lions that escaped from a petting zoo nearby and he's not dangerous" or "if I had a gun and was trained in shooting, I'd be better off right now." There is no time for us to set goals, gain a skill set, make a wish or hope for a tamed lion. We must fight or flee. Those are the options. We're very good at this strategy because we've even retained it without daily mountain lion threats.

We apply this strategy to everyday life as if the economy, kids homework or a promotion is a mountain lion. Running your brain and body on flight or flight at a maintenance level is why cardiovascular disease is the number one killer by leaps and bounds over cancers and accidents. We're not supposed to be leaping and bounding all the time. Our commute or the kids whining or the dog barking isn't supposed to use the same resources as fighting a mountain lion. It's such a primitive response, it can be argued that is it just plain immature of us.

Fight or flight, a function of the autonomic nervous system, is not subject to conscious control and in fact is the bridge between our mental life and our physical one. Maturity and the lack of anxiety is a state where there is a gap between our higher brain functions and our reflexive ones. We don't get to have a temper tantrum at work and in fact that is in the policy manual, so we have an imposed gap there but the gap is squeezed shut if we have road rage on the way home, take it out on our kids when we walk in the door, or eat and drink ourself into oblivion to prepare for the next day. We've become ungapped. I know I made up a word there but you're making things up too -- none of our everyday functions require fight or flight. In fact, it's a massive waste of energy.

The other thing that is occuring is that we are in an unfair fight. The system doesn't care if we work ourself to death or ruin our relationships along the way. In the end, no one will care and the so called "emergency" is long forgotten. It's the same with the mountain lion. If the lion is unsuccessful in killing you, it has missed lunch. If the lion is successful, you have lost

your life. That's not a fair set of outcomes - the fight means way more to you than the lion. The lion just shrugs it off and thinks "there's plenty of other lunches out there."

In the brain, timing is lopsided as well. This autonomic response quickly overrules the calm state but it takes the calming cures much much longer to overcome the quick trigger. Just take digestion as an example - an anger response triggered by traffic on the way home will quickly stifle digestion but the cure, eating, will take a prolonged effort to wake up the digestive tract and feel satiety. In other words, we overeat because it takes so long to rebalance the brain. Thus the cure becomes an additional problem in and of itself. It's got a big gap to bridge and is on a different clock - a slower one .

What is little known, or unremembered, is that there are other responses to stress. There are defense mechanisms just like flight or fight that are meant to be used on a maintenance level. We've likely forgotten "freeze and feign" wherein we are paralyzed and feign our death when threatened. It's called stonewalling because we build an imaginary wall around our emotions; we shut down, leave the room, or play "dead" by staring off into space when confronted by co-workers, bosses, spouses or our children. It's like playing dead at work - just clocking in and clocking out, having long lost our commitment, never mind passion for a job. It's another maladaptive response to stress and threat having its own health problems that are more chronic than a sudden heart attack. Circulation problems (blood pressure either low or high), digestive problems, breathing disorders and even the slow parade of cancer growth are the eroding link between cause and effect.

There's other responses such as the adaptive "rest and digest" which should be the reward after a big stressor, or even a days work, much like the lion would sleep and digest after a kill. But we are more likely to keep fleeing and fighting through the night, wracked with insomnia and indigestion when our version of rest is to watch violent television shows or hyper competitive video games. There's also the maladaptive "fight

and bite" responses which we have translated into overeating or grinding our teeth, yelling, over-explaining or biting our nails -- anything to express the bite response except by actually biting someone (really not advised). We might bite off more than we can chew, swallow our words that we'd love to say to our boss or fight tooth and nail for a promotion or even blurt out an ultimatum during a trivial quarrel. We translate primitive responses into modern ailments. From the vasoconstriction of our arteries to shunt blood (which in the worse case is called a heart attack) or fleeing by driving to jobs too far away or taking vacations that are more work than work itself. All of this to pay hundreds of dollars for entertainment, watching other people sing, play instruments, act in movies or compete in sports or talent shows while we sit. We pay to watch people perform at the very things that should be curing us if only we were doing them. Our sedentary habits of watching other people move (sports on TV), navigate (video games), problem solve (TV detectives), even make meals (cooking shows), all lead to funding the medical system with a sedentary lifestyle being more damaging than being a smoker. And remember, some of us pay in other ways besides the medical system. We pay for designer meals that are actually foraged food. When nettle soup is $20.00 a bowl at our restaurants, remember they got that nettle from your yard. The yard you just paid someone to weed.

The response that is adaptive and the one we'll use to self-rescue if lost, is called Tend and Befriend which elicits high doses of oxytocin. Historically a female response to threat, it is the hugging response, the hug found even in the circling of the wagons, of putting our arms around the wounded to carry them out of danger, to the tending to children and partners, and of befriending ourself by cozying up with pillows through the worst of times. This is the response we will need when we find ourself lost whether it is in the woods, immersed in grief, the aloneness after a betrayal, or struggling to reinvent ourselves during what looks like an abysmal future. Once lost, we have to

find ourself again. We have to focus on being found. If we remember one thing, *remember that hope can never be as lost as you are.*

This type of thinking is seen in the survivor personality. They have a strong affinity for "open brainness" - they don't impose pre-existing patterns on new information. They are the entrepreneur personality, the inventor, the strategic risk taker. They re-shape their mental maps quickly while people with "lost behaviors" insist on the status quo even if that status quo is a distorted map. Interestingly, survivor personalities know that life is not fair so they don't rely on luck or circumstances -- they change their luck and they change their circumstances. They are quick to laugh at their situation which employs large parts of the brain, twisting complexity into a punch line, shape-shifting emotions from perplexed to funny. Punch lines are literally something you didn't see coming. A nimble brain, used to "finding the funny," is the difference between a personality that is "discovered" from one that is "trained." Discovered personalities are open to new ideas and novel solutions while trained personalities are limited to what they were taught and what they've seen before. It's the difference between being a survivor and being a victim. We know the personality when we come across it -- they are the people who thrive despite horrible childhoods; rise from disaster; and find healing during a medical crisis even when faced with no cure. In the woods, it's the difference between shifting to direction finding (called "wayfinders") or remaining helpless, looking at the woods with a phenomenon called "nature blindness." One can see the forest for the trees while the other can't see the forest, the trees nor their way through any of it.. Status quo means you are going to stay right where you are. In our case, that's lost.

We know this is the same personality that emerges from a great grief. As they navigate through Kubler-Ross' stages of grief known as denial, anger, bargaining, depression, and acceptance, we should recall that Kubler-Ross recanted at the

time of her terminal diagnosis agonizing that the stages were in no way linear. You don't integrate each step and move on to the next. As she noted, sometimes she blurred right through the whole of them every five minutes. The nuance about those who climb out of grief into healing is that there are those who don't make that climb. It is thought that there is a profound state known as "complicated grief." It is marked by intrusive memories that are unwelcomed; distressingly strong yearnings for life to be like it was; and a wish that you were someone else, somewhere else, anywhere else. This is where you have entered a time warp. Your future has become your past with memories of the life you were to live and your past has become what will haunt you, making up the entirety of your future. It occurs in people who have merged too wholly into another or even into another magical version of their prior self. It is nearly incurable. We know also that friends and family or counselors will throw those grieving a rope. As they sit at the bottom of a dark pit, they are the only ones that can make the climb. Hand over hand, it is they alone that have to believe the rope brings them to clear air. As the entire world is on lock-down during the 2020 pandemic, we all sit at that bottom, alone, cut from our usual ropes and we all are asking ourselves "who am I when I'm alone." And we are hoping to be pleasantly surprised at our recovery. We are all hoping we find a new way to work, a fair distribution of resources and profound insight into who we are.

So this guidebook can be seen as a remembering, a way of knowing that our responses can be different, a plea to trust in something we might already know and that is this -- wisdom is different than reason. We all know smart people and likely we know that many aren't always wise. They can acquire vast knowledge but they may lack intuition, the ability to read the environment or glean from social cues. This can be lethal in the woods as they have the type of "smarts" that cannot adapt to changes in information. We won't outsmart the woods; we will have to learn the language and it's not going to be found in

a book (well, it will be found in this book but....you know what I mean.)

We are going to circle the wagon as we ponder these pages. We will demystify skies and forest. We will read the language of stems and leaves. It's as if we are in a play and like all good stories, we will go on a heroes journey. Act One the hero gets into trouble. Act Two the hero struggles and Act Three the hero gets out of trouble. We will turn fear into wisdom which usually happens at the near tail end of Act Two when you seem farthest from your goal. But in the last act, you will come out a different person. We can reclaim what other lost souls have known and then do what they have done: we will claim our new selves. That's the victory.

MAXIMS

Maxims are by definition short, pithy expressions of a rule of thought which is exactly what we need when we are lost. Since it's impossible to memorize all plant names and positively identify them, a few maxims will serve to get us out of any situation and any forest we might find ourselves. When you know that *ALL SQUARE STEMS* are edible, you've now opened up the possibility of finding over 7000 species of plants you can eat. If leafy plants aren't in the surroundings, the maxim ALL GRASSES are edible or the fact that *ALL REEDS AND SEDGES* are edible can be a life saver. *ALL CACTUS, ALL SEAWEED, ALL CONIFERS, and ALL INNER TREE BARKS* can be eaten. *ALMOST ALL INSECTS, ALL EGGS, and ALL DIRT* (yes, I said it. I said dirt) are edible.

The maxim that *ALL CONIFERS ARE EDIBLE* coupled with *NEVER EAT A BERRY*, protects you from eating the yew tree. Unless of course it's not fruiting season. Yews are highly poisonous, with cardiac death within hours of eating. Their needles are flat, are light green on one side and dark on the other and are more of a shrub than tree. So what's a forager to do? If a conifer's needles are not round, remember if *leaves are flat, leave it at that*. Other conifers all have round needles attached to the branch either by a suction cup or in clusters of

at least two needles. The color does not vary on the needle. Pine cones do not appear on the yew - the seeds are inside the red berry and are the hidden killers. *Never eat a shiny leaf, a milky stem or a berry. Never eat a plant with red splattered stem nor a plant with leaves in sets of three.*

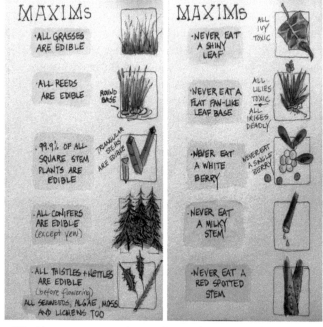

What increases your chance for survival is the efficient use of your energy. That requires judgement. So instead of learning that plantain is edible, knowing the *maxim that all square stems are edible* increases your diet from one plant to 70,000 opportunities. The *maxim that all triangular stems are edible* opens up tens of thousands of species (sedges have edges). From needing to find one identical species that you read about in a book to applying that knowledge to a similar but novel situation has opened up a whole new world to you. For now, that's all we need to know. Since you can live nearly a month without food, our focus can remain on re-orienting ourselves.

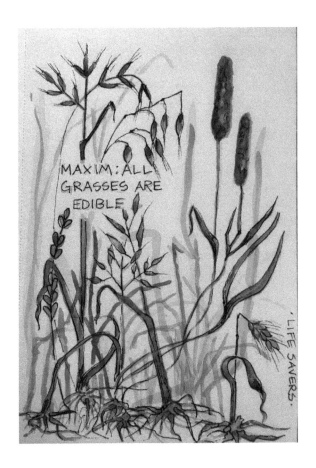

NAVIGATION
when you don't know where you are or where you are going

If you have been confused about where you are for thirty minutes, you are lost. The worst thing you can do at this point is panic and worse yet, frantically thrash through the woods. You must fight against the physical urge called "rescue fever" or "get there'itis." Rescuers call the failed attempt "trail running" - going back and forth on trails, never orienting yourself to the

right path. Another sign you are lost is the mental phenomenon called "bending the map." If you find yourself making excuses for the terrain such as "the path was supposed to be right over this hill" or "the creek used to be to the right but it's gone now," you are in the state of confusion called "woods shock." You are literally bewildered and you are misleading yourself. Your mental map is not accurate and you're leading yourself down a path of "more lost." You must snap out of it. You must admit you are wrong. You must take charge, focus and realize that lost is not about location, it is a failure of the mind.

A delay in fully deciding you are lost might find you circling, not realizing it, convinced you will walk back to a familiar bend, even back to the parking lot where you left your car. But rescue teams know that a lost person rarely circles round. Instead, they put one foot in front of the other veering offsides, trekking further and further from the path. Day hikers take a side trip hoping for a photo opportunity (called a "social path"); they walk too far and miscalculate the time to get back, and now it's becoming dark; they misread a path and are on an eroded rain gulley (called a "water bar") or animal path that leads to nowhere (called a "use path"). Worse yet, the trail could lead you to the animal; an angry one. The quicker you realize you are lost, the sooner you can prepare to live. A full three-quarters of the people who are lost, perish in the first 48 hours and are found only 2 miles from where they went wrong. That's not going to be you. Admit you are lost and you start to be a survivor.

The word lost comes from the Norse "los" meaning "the disbanding of an army." In other words, soldiers have fallen out of formation and gone home. Ah, if only being lost meant we were on our way home but we are not. We have certainly strayed from our mission and fallen out of formation but we have to work to find our way home. The first thing we have to do is one of the toughest. We have to figure out where we are - not in relation to the path we were on, but where we are right

now. We have to get our bearings. We have to OODA and we have to OODA quickly.

OODA stands for **Observe-Orient-Decide-Act**. The concept of the OODA Loop was created by United States Air Force Colonel John Boyd. It is a decision making tool used to make effective decisions based on the risky situation we find ourself in. The first step is to **Observe** our surroundings and take into account the conditions around us. The second step is to **Orient** ourself and understand how quickly our risk clock is ticking. The third step is to **Determine** the best course of action to improve our current situation. Finally, the last step is to **Act** on our current analysis. This process repeats until the crisis has passed. Search and rescue teams say people get lost because they don't pay attention. They don't turn around every once in a while to see what the scenery looks like on the way home - they just march forward. They stray too long on an animal path that ends at a den or they follow a stream but come to rapids or a dangerous rock cropping, forgetting how to backtrack. They fail to note landmarks (and what they look like from the backside), they don't pay attention to the time until it is too late, too cold and too damp. Their surroundings become terra incognita, suddenly unrecognizable. And suddenly inhospitable. Even a labyrinth has a simple solution - place a hand on a wall, don't take it off and you will find the exit

The first course of action is to insulate our clothing and seek shelter- think in layers. Most of those who get lost die of hypothermia, not dehydration and certainly not starvation. We have to become expert in the survival strategy called behavioral thermoregulation. In other words, don't get too cold and don't get too hot. We have to behave our way into the shade during the hottest parts of the day and act to insulate ourselves during the coldest.

To make shelter, stack or lean wood or leaves or even grasses to huddle under. This means you've also found food as all of those supplies are edible. If we've found leaves and grasses, they contain a bit of water. Once shelter is secured,

we can find more varied foods and begin collecting dew. If you have determined that you are indeed lost, it's best to realize this by mid-afternoon. The decision clock is ticking loudest then and the sun is about to give you its last bit of heat. All decisions now focus on shelter. In the days that follow, it will be critical to follow a tight schedule. As Daniel Boone was thought to have said "I never was lost in the woods in my whole life, though once I was confused for three days." We have to get unconfused. If you follow Tao, you know to carefully undo the situation you find yourself in. You would not apply undo force nor acquiesce meekly to fate.

If we've found shelter, we are either under a tree (avoid being under old branches that can break off in the night breeze - they are called widowmakers because that's what they do) or have woven together leaves or piled boughs atop one another. We've piled leaves, feathers or grasses over us for insulation. If we've found feathers, remember they are exactly what is in our pillows and comforters at home - down filled means feather filled. It's not intuitive but a hollowed out tree is sturdier than a solid trunk (like the design in bones) so building a shelter there is a good tactic. All *reeds and conifers are edible* so by finding shelter, we've found food. By eating leaves, we have the water contained in them. By placing leaves on our shelter shaped into funnels or rain gutters, they will collect dew and thus provide us with plumbing for fresh water by morning. By making shelter, we've found food and water. Now all we need is a good night's sleep. We'll be finding our way home tomorrow.

So the first night has likely been a troubled sleep but we've found basic foods, collected some water and can now begin to orient ourself. Most people lost in the woods will be rescued within 24 hours so it's best to stay put and not attempt self-rescue. But that assumes one critical thing that had to happen before we ever stepped onto a trail -- we had to have told at least two people where we were going and when we'd be back. Two people because one might not mobilize the

troops in time, thinking we're just delayed or they are embarrassed to have panicked and bother the authorities.

If no one knows we are gone, we have to plan self-rescue. Only you know where you are and actually, you don't even know that right now. You don't have a map, you don't have a compass, you are turned around from whence you came. How does one figure out where they are?

We are going to read the woods. There are dozens of signs in nature that we'll translate and soon, be literate in reading our way home. We have to figure out where north, south, east and west are.

Most of us have heard that moss grows on the north side of rocks or trees. But that's not as sound an indicator as we've been led to believe. Moss can be on any side of a tree if there is enough moisture. If a surface gradient is shallow, rainwater will run slowly off it and moss will thrive, regardless of direction. Equally, if a surface is coarse, a rough bark for example, then water is slowed on its descent and moss will settle in this moisture. The air within 60 centimetres of the ground is always moist since water is constantly evaporating from the ground – so if navigating by moss on the side of a tree, it is best to ignore any moss this close to the ground.

If water is dripping from overhanging branches it will likely create a perfect environment for mosses to thrive, even on a south-facing wall. So while mosses are a wonderful signal since you've found a great water source, do not rely on moss for direction unless it is well over 18 inches high on one side of a tree. If it is, that's the direction north. Since we're not always going to have moss to signal direction, we have to have more signs.

Burrowing animals will pick the soft north side that remains damp, puddles will have a green algae on the side with less sun, flowers in fields will bloom first on the south side and lichens will be brighter on the side with more sun essentially giving you a color compass. As Tristan Gooley, master navigator of land and water says, "south is sweet" and notes

you will find sweeter fruit on the south side of the tree and more color in leaves where the sun hits it. That's south.

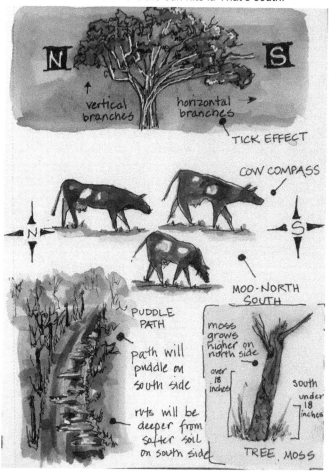

Graves are lain east/west (to better carry the souls aloft) while tennis courts are north/south (to give both players the same sun disadvantage as they switch sides). While we certainly aren't going to find these signs of civilization (otherwise we wouldn't be lost), it's an example of direction that we overlook every day. And the forest has many, many

more. Trees grow horizontal branches on the south side, vertical ones on the north side. The tops of trees can show "wind combing" telling you the direction of prevailing wind which usually comes from the west. Water fowl nest on the west banks, high clouds move west to east and spider webs are usually built on the south side of trees. The downward facing flower of some plants is a signal that you are in an area of turbulent weather. They naturally point down to protect them from ultraviolet rays and hard rains or wind that would scatter their pollen. They are a good signal that you should head for safer ground. They went to all the trouble to turn themselves upside down; you should take the signal and turn around.

Shadows can be too unreliable and can point in all directions especially in a craggy forest.

The point is, hold on to your bearings once you find them. There are many natural compasses out there. They will point you home and in fact, by now, the signals should be so loud and so evident that they are like a friend speaking in what was once a language foreign to you. Indeed, they are speaking to you; but this time, you can understand them.

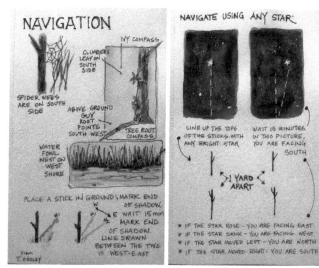

NAVIGATION

IVY COMPASS

CLIMBERS LEAF ON SOUTH SIDE

SPIDER WEBS ARE ON SOUTH SIDE

ABOVE GROUND GUY ROOT POINTS SOUTH WEST

TREE ROOT COMPASS

WATER FOWL NEST ON WEST SHORE

PLACE A STICK IN GROUND; MARK END OF SHADOW. WAIT 15 min. MARK END OF SHADOW. LINE DRAWN BETWEEN THE TWO IS WEST-EAST

from T. GOOLEY

NAVIGATE USING ANY STAR

LINE UP THE TOPS OF THE STICKS WITH ANY BRIGHT STAR

WAIT 15 MINUTES. IN THIS PICTURE, YOU ARE FACING SOUTH

1 YARD APART

* IF THE STAR ROSE - YOU ARE FACING EAST
* IF THE STAR SANK - YOU ARE FACING WEST
* IF THE STAR MOVED LEFT - YOU ARE NORTH
* IF THE STAR MOVED RIGHT - YOU ARE SOUTH

As we are making our way out of being lost, we'll leave navigational landmarks and signals for the rescue team. You have to speak to people who can't see you yet. Much like you'd tell your friends or family the signs of you being too stressed, overly anxious, heading for depression or sinking back into grief, you need to tell rescuers how to help. Many of us are clumsy at asking for help or telling people we're in trouble, hoping that they are mind readers and those who die in the woods are the worst at it. Obviously. Their inability to speak out has killed them. Men, especially, refuse to admit they are lost, fail to tell friends and family where they are hiking or hunting and many have told stories of being lost and being too embarrassed to even approach a cabin with lights on. That same psychology is why you tell two people your plans and time expected home. Each has a different threshold and risk tolerance to call the rescue team. They can be too embarrassed to call for a premature rescue. So assume you are on your own.

Survivors do something elite athletes do - they make short attainable goals and that alone can lower their energy

expenditure by a remarkable 10-20%. We need to focus and conserve. And we need to tell rescuers where we are going.

Myths and fables tell of a lost soul wandering through a labyrinth or dark forest and leaving a line of thread to find their way back out. We'll assume we don't have an endless line of thread but we do have other ways of signalling our trajectory. We can leave a line of carefully placed signals such as deliberately folded leaves, twigs made into a directional arrow, a pile of rocks showing our direction or even writing into bark or dirt. We can use a soft rock like a writing tool, grinding a message into a harder rock, using our spit as a mordant to make the mark semi-permanent. Our spit has enzymes that can lubricate soils and leaves into pigments and inks when nothing else is available. Using the egg whites of birds or reptiles can make a permanent ink when mixed with clay, ground rocks, the bark of trees, berries or acorns. By leaving a trail with the objects at hand, rescuers can follow our direction. We need to tell them our mental plan with physical markers.

Just as we would track an animal from their prints in mud or snow, even following dung to track a herd, we can leave traces as well. To trackers, this is called "trail blazing" - we can dig letters in the dirt, or carve arrows or our initials in the bark. These signs and signals can also tell us that, after hours of trekking, we've merely returned to a spot from which we left, a signal in and of itself that we are not keeping to an accurate

compass. Always follow the natural navigation signals whether it be looking at tree growth, watching wind patterns, observing moss height, or adjusting according to the suns path. If the sun was behind you and after trekking a few hours it is in front of you, you've lost track of your direction.

Some tribes retain a navigational compass by naming their body parts "my east arm" and "my west hand." This keeps them oriented within their very body and one would know that on the way home, their east arm is now their west arm as they look for all the landscape details that would verify they are headed in the right direction.

It is said that there are no areas in the United States that are more than 20 miles from a road. If you were to venture to walk straight ahead, navigating that 20 miles to civilization, no compass nor map would tell you the terrain you must cross to get there. It might be the steepest, most dangerous 20 miles in the area as the crow flies. Knowing that we burn about 200 calories per mile, we'll require 4,000 calories a day which is near impossible in a foraging situation. You don't have an easy 20 miles in you nevermind a treacherous 20, unless of course at the end of that 20 miles you are found.

Natural signs can signal distance using atmospheric perspective, the phenomenon wherein colors drop out of our eye's perception. Red is the first color to disappear, then yellow, orange, and green until only blue is left. Viewing a distant range or tree line and seeing no details but merely a blue haze, you know you are, at the very least, 20 miles away which is likely too far away for an exit plan.

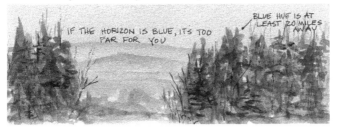

The trouble is, once a landscape has faded to blue, it can just as well be 40 miles. If you can still see red soil, coral flowers, or maroon leaves of trees, you know that's about a mile away. If you can no longer see red or orange, only yellows, you are 3-5 miles away. If everything is a dim green and you can no longer see individual trees, you are ten miles and if blue, you are at least 20 miles away from that landmark. Those are estimates based on air quality and sunlight, but a good enough rule of thumb to decide if your plan is foolhardy. If you see a range of mountains or trees and they are purple, as in "purple mountains majesty," you are 40 miles away at the very least. They cannot be your plan for finding yourself at home snuggled in a down comforter with a hot meal in front of you.

If you see birch or alder trees, know that they grow near the outer edges of a forest or wooded area, thus, you are coming to a clearing. If you see cottonwood, know that they signal a place where the river or creek swells, telling you it's not a good place to camp should the water surge at night. Merely camp away from cottonwoods or on the other side of the creek.

PREDICTING WEATHER

Predicting weather helps us make critical decisions, eliminating the element of surprise, which is an emotion we can ill afford. Knowing that certain clouds signal calm weather or can warn of a storm in the next 24 hours, it tells us to continue walking until it's time to build shelter at 2 or 3 pm or tells us to begin shelter building now no matter what time of day it is. We measure our energy levels everyday when we are home, plotting our day's activities accordingly. If we have a critical discussion coming in the afternoon, we ease up on our morning schedule, perhaps having the wherewithal to eat lunch on time, stay away from an afternoon coffee so we're not more pressured than necessary and putting off errands that can wait another day. With children, we measure for them, getting them down to an earlier than usual nap, reading them a book to calm their emotions or run them around the park to physically exert them. We pace our day by reading our physical and emotional signals. If we become too tired, over hungry, irritable or spacy, we haven't read our signals well and we've undermined our performance for the rest of the day. You can't afford this on a good day and you certainly can't afford it out in the woods. .

We have to read signals before they become critical because undermining our performance won't be merely "having a bad day," it will be our survival that's at stake. Timing is everything and nature can tell us when to set camp early or when to keep one foot in front of the other. It's like being told we need to take a nap before we have a full blown melt-down.

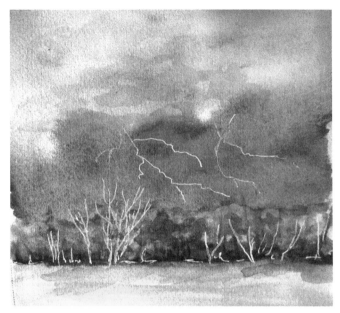

Thunder can be heard 10 miles away (15 if there's very clear atmosphere or you are near a canyon) so if you hear a clap or two, know that a storm is within striking distance of your camp. To determine distance, count the seconds between lightning strike and thunder, divide by 5 and you've got a "flash-to-bang" reading. Five seconds, the storm is 1 mile away. Anything under 30 seconds, find cover as you want to be no closer than 6 miles from a storm. Wet clothing, soaked fire starter, and damp insides of your shelter are not going to contribute to your survival in a good way. Try to get to a spot where you can see lightning but not hear thunder.

Watching how leaves, dust or smoke move can predict weather as well. If the trees and leaves around you are still, you can anticipate calm weather. If the smoke drifts away from your fire, or a kick of dust swirls up and away, wind speed is 1-3 MPH and the air is considered light. If leaves rustle and you can feel a breeze on your face, it is a light breeze at 4-7 mph. Should twigs move, it's a gentle breeze of 8-12 mph.

Moderate breeze is 13-18 mph and small branches move along with dust rising from the ground in visible gusts. Small trees swaying shows 19-24 mph, and large branches moving says winds are 25-31 mph. Whole trees moving is 32-38 and considered near gale. A small craft advisory takes effect at about 25 mph or 21 knots so if you are a sailor, you can get an idea of the level of danger these wind signals are indicating. Tailwind can add miles to your day with very little effort and requiring fewer calories to support those miles. If it's a head wind, your trek should be discontinued -- you may not find the calories to justify how little you've travelled forward.

We are walking barometers with rising and falling energy levels according to the coming weather. In heavy, burdensome air, we feel lethargic, signaling that the barometer is dropping and a storm may be approaching. If we see cloud changes which support that, we need to stop and prepare shelter. If we are feeling light and energetic in crisp air, a high pressure system signals optimal weather. We might be able to get extra miles in on a day like this. Animals are busier with high barometer readings with ants moving faster, or deer more present. In hunting, 85% of record book bucks are killed during high barometer days as they are out and about making them easy targets.

We may see game grazing non-stop rather than taking rests which signals a storm in 24 hours as they gorge to stock up. If we see no game when usually we could spot them, it's time to hunker down. Spiders abandon their webs, birds are less vocal and hang out in lower branches, clovers close up and if our hair is frizzy, hands or feet are feeling very slightly swollen and leaves are curling or stems are drooping, a storm is coming.

Smells are intensified just before a storm, with the woodland debris more pungent as plant waste releases gases. Swampy areas would smell like rotten eggs and pine cones would close up tight in preparation for a storm .

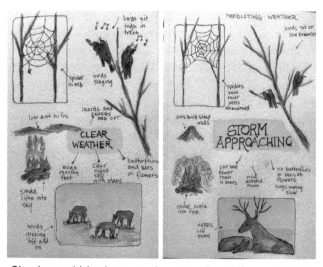

Clouds would be lower to the ground and if gray, indicate a light storm. If black and bottoms are flat, a storm with strong winds are predicted. If you see a rainbow in the west, the rain is heading toward you; if east, the storm has passed around you. You must keep your eyes peeled for changes in case you have to take shelter sooner than later. If you notice no bugs, the branches are moving in the wind instead of moments ago when only the leaves were rustling, you know the weather is progressing.

At night, you can still predict tomorrow's weather. Storms are approaching if a halo is around the moon and if a double halo, winds are coming with that storm. Fewer than 10 visible stars tell you that cloud covering is accumulating and a storm could be here by morning.

Many stars means clear weather tomorrow

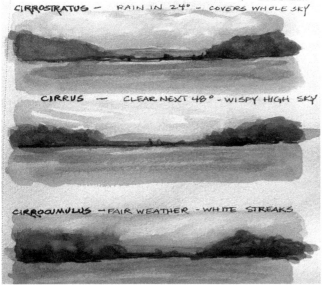

CIRROSTRATUS — RAIN IN 24° — COVERS WHOLE SKY

CIRRUS — CLEAR NEXT 48° - WISPY HIGH SKY

CIRROCUMULUS — FAIR WEATHER - WHITE STREAKS

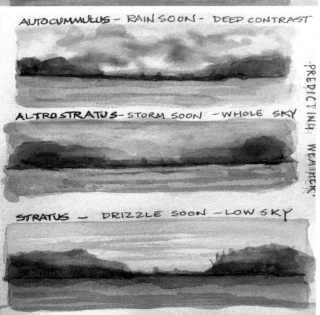

AUTOCUMMULUS - RAIN SOON - DEEP CONTRAST

ALTROSTRATUS - STORM SOON - WHOLE SKY

STRATUS — DRIZZLE SOON - LOW SKY

'PREDICTING WEATHER'

PLANTS THAT ARE LIFEBOATS

There is such a thing as a survivor personality and it includes people who avoid accidents in the first place. They conduct themselves like survivors, reading signals early and adjusting quickly. This needs to be who you are now. Plants have a survivor personality as well and adapt to thrive in most forests and woodlands across the U.S. You need not know their name, their habitat nor their nutritional value. They are at your feet disguised as weeds. Most every forest in the U.S. has dandelions, plantain and dock that occur from timberline to valley. Interestingly, each of those have plenty of sodium in their roots to save your life. If all else fails, you can lick the salt off your skin to survive. If this is all you've found, you have plenty of nutrition and even medicine to make it home.

DANDELION
found from the tree line to the meadow in nearly every forest in the U.S.

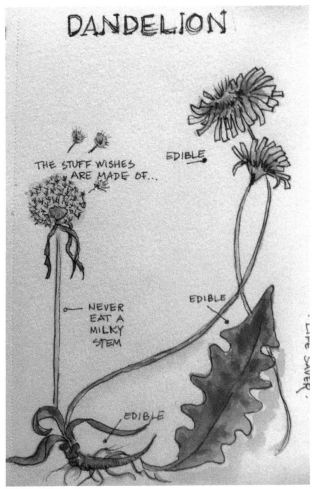

DANDELION

THE STUFF WISHES ARE MADE OF...

EDIBLE

NEVER EAT A MILKY STEM

EDIBLE

EDIBLE

LIFE SAVER.

Remember that all grasses are edible, all reeds and sedges, most every tree, leaf, twig, the buds on those twigs, both inner and outer bark, all kelp, all cactus and that tens of thousands of species with square stems are edible. That's not even mentioning that most bugs are edible, as well as all animals, all

birds, and all eggs, giving you a meal in the form of 100's of thousands of species. Some plants are super finds. One plant is so useful, it is called The Supermarket of the Forest - the cattail.

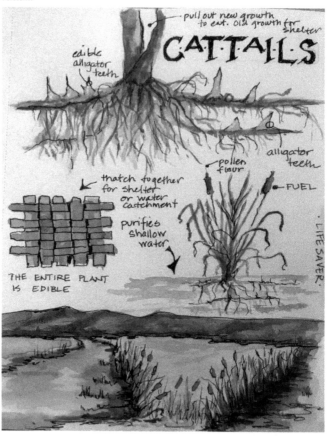

They say if you've found cattails, you have four of the five basic requirements for life. You have found water, and usually purified water at that. You have shelter (leaves), fuel (cattails -can also be used as a diaper), and food (leaves, roots, pollen). That just leaves one thing missing: Friends. There's no emotion more crippling when lost than the knowledge that you are so very alone.

If you've ever crawled your way out of grief, made your way through the barren desert of one disappointment after another, or felt like you were knee deep in a quagmire, sinking back to thoughts and emotions you thought you had left behind, you know how alone someone can feel. But since you are reading this, you've found your way and likely you've found people or even just your own thoughts to help cushion your re-entry. People or aphorisms can be a lifeboat. Plants are like that too. And some surprise even the best of experts.

Plants in the legume family such as vetch or lupine (almost all legume plants or seeds are edible and they are the third largest plant family on earth) additionally have a superpower other plants don't have: They set nitrogen in the soil which means they serve to fertilize a storehouse of plants around them. There's only three ways to set nitrogen. One is fertilizer. Two are legumes. Three is lightning. So legumes are one in a trio of life-giving super phenoms. When Mount St. Helens erupted in Washington in 1980, the volcano left a mile wide crater. Scientists made lists of plants that would return but were surprised to see the first sprout was a lupine. It wasn't on anyone's list. Then surprise of all surprises, a mouse visited it. A mammal! They had thought insects or birds would be the first animals to return -- something with wings. But it was the lupine and a mouse - interestingly, both nitrogen factories. Lupines became known as a lifeboat plant, the plant that

escaped the disaster and in barren miles of ash, became a safe haven to repopulate the crater with plants and animals rescued all around it. Who knew? Well, no one.

Thus a whole study emerged looking at plants that are the first to thrive in destroyed places or wastelands. What makes them particularly stalwart? And interestingly, why are they all edible or attract other plants that are edible? I think we can all name friends like this -- they've been through the gates of hell and returned to gather us up and guide us home. In the plant world they are called "primary succession" species and the plants they give a boost to are called "secondary succession" species.

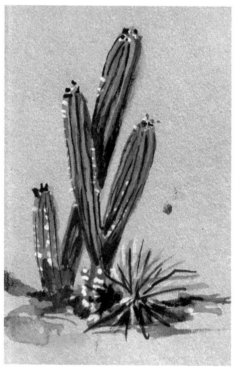

Cactus are such species as are all of the edibles. Thus, food is all around you just like a cadre of best friends.

TWIGS and BUDS ARE EDIBLE

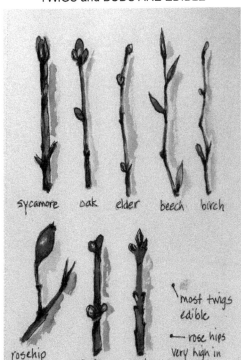

sycamore oak elder beech birch

rosehip maple ash

most twigs
edible

— rose hips
very high in
vitamin C

 Snap off the light green tips of conifers to eat or if it's not springtime, pluck off the round needles (never eat a flat needle) and either chew on them or boil for tea. The inner white bark is edible and offers energy producing carbohydrates. Unless in a starvation situation, chew the bark as if it's gum, spitting out the stringy shreds once you've gleaned all the starch from it. The sap is waterproof, allowing you to patch clothing or glue leaves together to make a cup or bowl to carry water. This tree is all you need to gain Vitamin C, which if absent from your diet for 3 weeks, will lead to scurvy. Most tree barks are edible and in a survival situation, well

worth the work to peel off the brown bark (also edible in a pinch) and get to the softer inner layer.

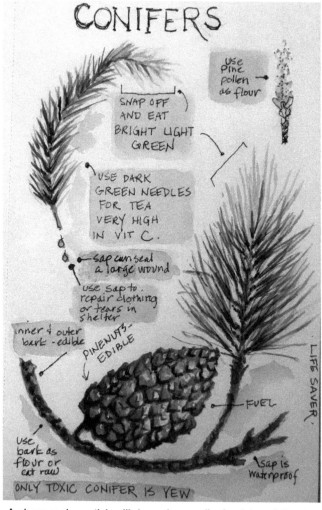

CONIFERS

use pine pollen as flour

SNAP OFF AND EAT BRIGHT LIGHT GREEN

USE DARK GREEN NEEDLES FOR TEA VERY HIGH IN VIT C.

sap can seal a large wound

use sap to repair clothing or tears in shelter

inner & outer bark - edible

PINENUTS - EDIBLE

FUEL

LIFE SAVER.

use bark as flour or eat raw

Sap is waterproof

ONLY TOXIC CONIFER IS YEW

A sharp rock or stick will do and even digging into a fallen tree will work. Peeled into strips, it's like eating jerky and is called Forest Spaghetti, substituting as noodles when boiled. Many indigenous people eat bark. The word "Adirondak" actually

means "bark eaters" and we eat it often, as well, in the form of cinnamon which is merely ground bark. Pinecones have edible seeds (pinenuts) and while both nutritious and delicious, can take hours to forage enough of them to make a meal.

Lichens and mosses are all edible (as is all seaweed and most algaes). They can be wrung out to provide water, used as fire starters or eaten if boiled. They can also be used as insulation between clothing layers and ground into flour. Indigenous tribes have lived off acorn flour for centuries with every species of oak offering edible and highly nutritious acorns.

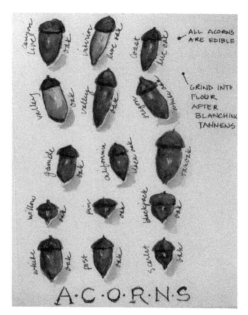

A·C·O·R·N·S

You might be wondering why I'm talking about making flour when I have emphasized that time is of the essence. Afterall, this is no time to be baking bread. And how on earth (literally) would you find yeast? Well that brings us to an interesting foraging lesson. Suffice to say that it is so basic, so mystical and so wondrous that I'm going to let you look it up rather than tell you about it. Look up why witches are depicted riding brooms.

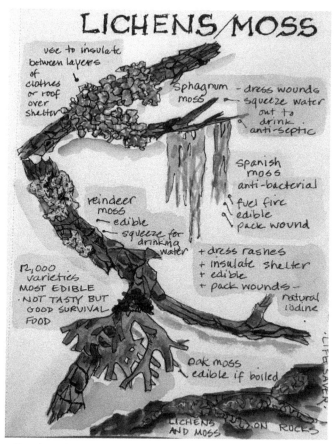

LICHENS/MOSS

use to insulate between layers of clothes or roof over shelter

Sphagnum moss — dress wounds
- squeeze water out to drink.
- anti-septic

Spanish moss
anti-bacterial
- fuel fire
- edible
- pack wound

reindeer moss
— edible
— squeeze for drinking water

+ dress rashes
+ insulate shelter
+ edible
+ pack wounds —

12,000 varieties
MOST EDIBLE
· NOT TASTY BUT GOOD SURVIVAL FOOD

natural iodine

Oak moss
— edible if boiled

LICHENS AND MOSS ON ROCKS

LIFE-SAVER!

Purslane is considered the most nutritious plant on earth and the only unprocessed plant that provides Omega-3 oils, found in the same quantity as fish and grass fed meats. One small handful is enough nutrition for a week. Find purslane and the rest of your trip just requires you to stay full, not nourished or worried about vitamins. Nettles have more iron in one leaf than a spinach salad. Iron is required for proper muscle function and since our iron stores can be easily depleted in a day, we're lucky that nettles are plentiful in most every forest.

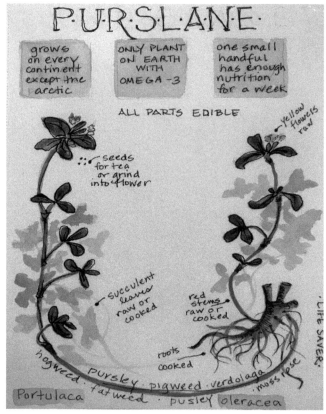

P·U·R·S·L·A·N·E·

grows on every continent except the arctic

ONLY PLANT ON EARTH WITH OMEGA -3

one small handful has enough nutrition for a week

ALL PARTS EDIBLE

yellow flowers raw

seeds for tea or grind into flower

succulent leaves raw or cooked

red stems raw or cooked

·LIFE SAVER·

roots cooked

hogweed

PURSLEY · pigweed · verdolaga · moss rose

Portulaca fatweed · pusley oleracea

Once you realize the basics are plentiful in most forests, it seems like Mother Nature made everything edible. And the plants that aren't edible have signature characteristics. *Never eat a shiny leaf. Never eat from a plant with three leaves on a stem; never eat from a plant with a spotted red stem.* Hmmm....what a wise woman Mother Nature is.

IT DOESN'T HELP TO COUNT CALORIES IF IT DOESN'T COUNT

When it comes to food, we are stomach deep in the middle of a math problem. We know that most people can live 30 days

without much food but that requires we have water which is hard to come by. Without water, leaves will have to provide both nutrition and fluids.

We require a substance level of about 1,500 calories a day to maintain our weight over a week. Most of us have weight to loose so in a sense, we're now going to capitalize on that food storage as usable calories - it's like you've brought a pantry with you. Some of us have little to no stored fat and the math problem becomes more critical. Decide now to expend only 60% of normal energy, that is you'll have to live on 500-750 calories a day and a ½ pint of water. The physical exertion level must deflate, you will have to rest often, cease to travel during the heat of day, find food and then continue to navigate. We have a forward gaze like other predators and thus we have the ability to focus on one thing, ignoring anything that gets in the way of our pursuit. We are not grazing animals where our eyes are set on the side with 350 degree (not 360) gaze, ever watchful of everything around us. Their eyes are on the side of their heads; ours are in front. We are built to focus on one thing.

The math problem involves not just the number of calories but also maintaining our body temperature -- not too cold and not too hot, either of which could kill us or waste calories. Two degrees off our baseline of 97.7 (not 98.6) and we can become hypo or hyperthermic. It's known that survivors do two things as soon as they realize they are lost: They create a very strict schedule and immediately begin maintaining their body temperature and energy stores. Building shelter very early, insulating the layers of our clothes with grasses or moss to maintain body temperature and sleeping well is the first order of business so we can work on an exit plan.

We must awaken before the sun rises to collect the water from last night if there is any. Start a rationing schedule for the water you have. Your lean-to shelter of boughs and a cushion of grasses or pine needles at least 8 inches thick, can be partially dismantled as it contains edible plants, grasses, reeds,

boughs or barks. If possible, leave a sign of a partial shelter to signal where you were both for your rescuers and for yourself in case you backtrack. Begin packing food. Stuff edibles in your clothing for insulation or tie leaves with reeds to the belt loops in your pants, even using the laces to tie a bundle to your shoes.

Since you are counting on calories to maintain your body temperature and it's likely you'll be on the wrong side of a maintenance level intake, you need to gain as much caloric benefit from each bite as possible. Most of us chew 5-6 times and swallow, which is far too few. Chunks of unchewed food enters our gastrointestinal tract which then has to be dissolved by the stomach as large chunks (you've seen whole kernels of corn or nuts in your feces - that means you never chewed that kernel one time nor was stomach acid able to dissolve it). The stomach doesn't have teeth to grind food but it does have stomach acid, which it will increase in order to make every surface available for absorption. As acid increases, we risk reflux and heartburn. Better to thoroughly chew your food so that the enzymes in our saliva meet every food surface. By the time we are finished chewing, we are swallowing a pureed mixture. Essentially, we eat solids, chew to a ground texture and swallow liquified baby food. Chewing should be 10 to even 40 in number if the food is fibrous. Let's assume all we can confidently find is tree bark on this first day. Foods like nuts, jerky, even most meat and in our case, tree bark, will release the most lipids only by grinding, not by stomach acid. Lipids or carbohydrates give valuable energy for walking ourselves out of the woods. Carbohydrates produce serotonin, that feel good brain chemical we need so badly.

When eating the white inner tree bark, called the cambium layer, chew it like it were gum, never swallowing the fibers unless you are in an extreme famine situation as the fibers are tough on the gastrointestinal tract. Cambium stores all the tree's energy, similar to how plants store energy in their roots, making it an excellent source of transferring that energy to

you. Failing to thoroughly chew will waste valuable energy and calories. You've wasted all the calories it took to find the food, all the calories carrying the food and all the calories attempting to digest the food. You've also wasted all the water it takes to digest and move food. Well, now you've really done it. By eating improperly, you are increasing your risk of dehydration. Digestion is a very expensive enterprise (remember how the body shuts down this big energy user when in flight or fight).

Muscles require iron to function properly and without adequate iron, fatigue, confusion, shortness of breath and our ability to maintain our body temperature will overrun all our efforts. Iron is the most common mineral deficiency in the world yet by mass, the most common element on earth. It also makes up most of our blood mass. You simply must find it.

We get iron from meat or fish but that's not readily available when we are lost. Luckily nature provides a most viable substitute – nettles - and they grow abundantly in most forests. Men need 8 mg of iron daily and since women menstruate, they need 12-18 mg per day. Spinach, one of the highest sources you can find in a grocery store, has 3.5 mg per 100 mg serving but nettles have a whopping 277 mg of iron and 169 mg of calcium.

If all that you have found is tree bark and nettles, you are well prepared to get out of this alive. That's it. Two foods and both abundant on most continents on earth. But there's another food supply, nearly endless in abundance in the woods and that is bugs.

Even if you were an excellent trapper and also able to whip up a fire at whim, it's important to remember that in a hunter-gatherer society, women gatherers brought the vast majority of calories into the tribe. In a survival situation, it is a waste of time and resources to attempt to trap or hunt animals. Your protein should come from bugs and your calories from trees and leaves, even grasses, as they are all edible. Besides, animals bite and while many lizards, turtles and snakes are most likely edible, the bite and wound they can leave are far

too much of a gamble -- they just don't have that much meat on them to make any risk worthwhile.

If it comes down to a true famine situation - you've found nothing that seems safe to eat, there are no bugs and no trees whose bark you can peel to chew on - you have one more food source. You are standing on it. Yep, I'm talking about dirt.

Dirt is eaten in many cultures, especially by pregnant women and adolescents. Called "geophagy," it is practiced on every inhabited continent, in almost every country, occurring every day all over the world. What's the deal? Turns out that soil, dirt and especially clay absorbs toxins, binds to heavy metals and protects against parasites, toxins and pathogens. It's like eating a protective shield and a weapon all at once. Our culture uses it for this very purpose, giving overdose patients a good dose of charcoal. In fact, we do ourselves a great disservice by overwashing our produce -- we are removing a light exposure to organisms while at the same time washing away the cure if in fact we are overloaded with organisms. Additionally, soil adds nutrients like iron, calcium and zinc and serves to fill the stomach, which is a mood stabilizer. A full feeling stomach allows you to think straight. You've suffered from the phenomenon called "hangry" before - an irritability brought on by hunger that makes one angry. And that's just because you've missed lunch. Imagine being lost and wasting precious energy on food fantasies rather than gathering food or worse, being so hungry you walk off delirious. Many a lifeboat survivor has told his mates that he is going to the store and simply walked off over the edge right into hangry shark infested water. It makes no sense and that's the point. We need to keep our stomachs feeling full to stay the course. Stay full even if you have to eat dirt. Once you realize that you are even standing on food, you've substantially narrowed down the uncertainties and surprises, two things the brain hates, and you can concentrate on your trip ahead. The present is accounted for. Concentrate on your future. Terra

incognita has become terra firma. And you may even be eating it.

TURNING YUCK INTO YUM

There are 2011 edible insect species with over two billion people in the world using them as part of their diet. The United Nations Food and Agriculture Department urges more of us to eat insects as they are the most abundant source of protein on earth, with dense concentrations of omega-3 and all the amino acids. Grubs and maggots have so much fat, they are like eating a ball of butter. Mealworms have the most protein with 100 grams of worms containing 24 grams of protein. Beef, at that same weight, has 26 grams while salmon has less at 20 grams. To digest protein, the body burns more energy processing it than carbohydrates or fats but, importantly, you'll feel more full than eating other foods. Crickets have 20 grams, more than a pork tenderloin and as much potassium as bananas (with only 1g of protein). One handful of fly larvae gives you 950 mg of calcium (you need 1000 mg a day), along with more zinc and iron than any meat or fish.

I can see you crinkling your nose thinking you'd never resort to eating bugs. But I have good news and bad news for you: the good news is you've already been eating them. Or wait...is that the bad news? The Food and Drug Administration (FDA) sets "filth standards" (their language, not mine) for processed food. This standard states how many insect parts, larvae, eggs, worms and rodent hair or poop are allowed in every 3.5 ounces of product.

I know you're hoping the number is zero, but it's not. Let's take peanut butter, the most regulated, controlled food on the planet. Every 3.5 ounces is allowed 3 insect fragments. For pepper, 40 insect fragments are allowed in every teaspoon. Golden raisins? I'm glad you asked as they are allowed 35 fruit fly eggs and 10 whole insects per 8 ounces.

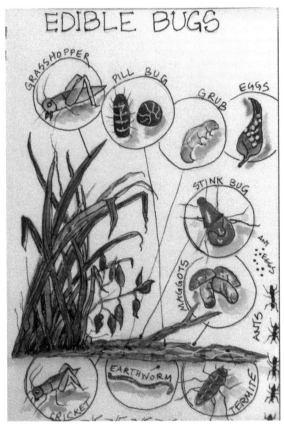

Tomato juice has 4 maggots and 20 fruit fly eggs and fig paste (the center filling in fig cookies) has the highest rodent hair allowance at 9 for every 10 grams and tops it off with 13 insect heads per 3.5 ounces. I'm not even going to tell you the amount for mold allowances except to hint that you should look up the numbers for black current or cherry jam. Hint: it's over 25%. So see, you already have a tolerance for insect parts and mold.

This part of "being lost" and the most reliable solution for food being in the form of insects is much like the advice one gets from a good friend or a therapist -- the advice is often so obviously true, so simple and so obscured from your

consciousness that you immediately discount it. If the advice giver says "you'll see in time that you dodged a bullet when this person is out of your life," the advice getter thinks "but I want that bullet" rejecting the obvious solution. Sometimes it's more comfortable to hold fast to our grief. But here's something we know about survivors and about successful people - their resilience comes from the ability to tolerate discomfort. Big goals are achieved through small, uncomfortable, and most often clumsy steps. And solutions, as advise givers are trying to tell us, are most often right under our nose.

Insects are easy to find and easy to "hunt" as they live under dead tree branches, leaf debris on the forest floor, or under layers of bark or rocks -- merely gather them up, pull off their head and eat or carry them for later. Their eggs can be found on leaves and appear like clusters of caviar.

 To trap bugs, place a container, a large leaf or a basket woven from reeds in a hole. Bait with berries if you are lucky enough to have found some or any bit of food, even other insects and place leaves and bark in the bottom so bugs can hide under them rather than escape. Make the trap at night and collect your hunt in the morning.

It's best to cook all insects, as they can carry nematodes or parasites, by placing them on hot rocks, speared with skewers or in boiling water. If you do not have fire, and insects have become your major food source, the risk of parasites is far lower than death from starvation or remaining so weak, you can't walk yourself out of the woods. During a crisis, we aren't guaranteed to emerge scar free -- we have to weigh the risks, calculating survival versus discomfort and one of those just "weighs" more than the other. We're choosing survival. If you've ever been grief-stricken, where you are literally stuck in the muck with paralysis and think you can't go on, you know that you weigh survival by the hour. Just get through another hour; just get through another meal; just get through another day. Grief and resignation can only be navigated slowly, putting one very small goal in front of the other until you

emerge. It's OK to take your survival in small increments -- just go one bug at a time.

Edible bugs when roasted are earwigs, scorpions, maggots, dragonflies in both stages, grubs, stink bugs, termites, grasshoppers, crickets, cicadas, june bugs, agave weevil, and mayflies. Edible bugs when boiled (roasting would decimate them) are maggots, pill bugs, ants. However, plenty of survivors have eaten raw bugs as their only food source and are alive to tell us about it. *It's safest to only eat brown, cream, tan, black, brown, amber, or green insects. Avoid colorful, hairy or smelly insects and all caterpillars.*

Many lizards and snakes are toxic, they don't have much meat on them and besides, they bite. Bugs are easier to catch, rarely toxic and very high in protein. Never eat snails, slugs, tarantulas, bees, wasps or caterpillars. While most are edible, hunting them is more dangerous. If you must eat snails or slugs, capture them and feed them edible plants for a full week. They eat many poisonous plants so you cannot eat them unless you keep them as a pet for a full week and put them on your diet. Best to just eat what you'd feed them and leave them alone. Why give them your food?

While mushrooms seem far more appetizing, they have around 5 calories (and that's being generous), no fat, 1 gram of fiber, and only 3 grams of protein. They can contribute very little to your survival compared to insects. And remember, you only have to be wrong once with toxic plants.

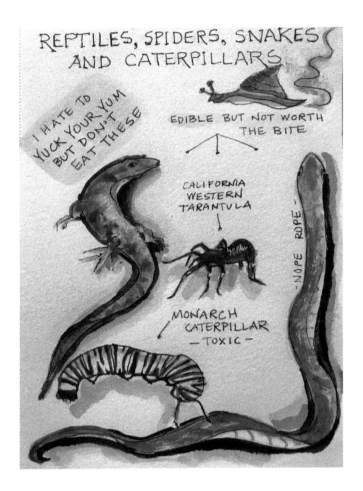

REPTILES, SPIDERS, SNAKES AND CATERPILLARS

I HATE TO YUCK YOUR YUM BUT DON'T EAT THESE

EDIBLE BUT NOT WORTH THE BITE

CALIFORNIA WESTERN TARANTULA

MONARCH CATERPILLAR — TOXIC —

— NOPE ROPE —

Mushrooms do have over 30% of vitamin D but remember, if you are lost in the woods, vitamin D is the very least of your concerns. If you are worried about vitamin D, merely roll up your pants and sleeves for exposure to the sun. Fifteen minutes of sun to your long bones (less if you are dark complected), and you have shattered anything mushrooms could do for you. So move on. Step away from the mushrooms. There are so many other options that carry no risk.

All eggs are edible whether it be insect eggs, bird eggs or reptile eggs. The sooner you can gather them after being laid, the more appetizing they are. Unless in starvation mode, take only one or two from the clutch (with insects you can gather most of them as there are thousands laid at a time).

Waterfowl nest on the west side of the shore

Hunger will guide you as you do something foragers call "turning yuck into yum" -- crickets are especially tasty as are grubs but you won't know that until you try them. It's wise to accept bugs as a profound part of your plan to get home -- they are walking, hopping, crawling protein. The quicker you can get to acceptance, the more stamina you will have to proceed. Resigning yourself is different than giving up -- this is what you are doing now. You are fighting to live. Succeeding at food very early will make you feel so alive you simply cannot die. You have to make that feeling bigger than your fear or your distaste for the food that is available.

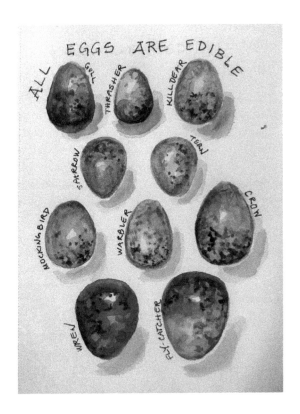

As in all difficult junctures in life, we cannot succumb to apathy or let discomfort make us quit. We've no hope of thinking powerful thoughts without powerful nutrition. Protein, in the source of bugs, is like eating courage for breakfast.

And one more thing: Just because an animal is eating something, doesn't mean you can. Birds can eat bugs and berries that would kill us.

WATER : no you don't need 8 glasses a day
I'm not kidding. Really if you say it one more time...

The most pervasive and equally unfounded recommendation in medicine has no basis in science. It is advice given by laypeople and experts alike and has to be the most unquestioned myth in health care. It sounds like this: "drink 8 glasses of water a day." It is impossible to find research to support the claim yet it persists, not only from diet and fitness gurus but from the vast majority of medical professionals themselves. A mediocre kidney doctor (not even a good one and certainly not a great one) will tell you that 8 glasses of free water is very difficult for your kidneys to process, dilutes the minerals and vitamins from your food and can lead to water toxicity. Your kidneys can process only 8 ounces of water every four hours or longer which would mean at best, you should drink 4 small glasses of water during your waking hours. What most are failing to calculate is that we gain additional water from foods like plants and animals. Packaged food like crackers, breads, cookies - well anything that comes in a package - has had the water removed. If you eat these foods, you will require more free water to process them, while remembering you aren't supposed to be eating those foods in the first place. They aren't real. But that is not your concern if lost in the woods. Many survival books will tell you to find water first and that we can live 3 to 4 weeks without food but only 3 days without water. What they fail to mention is that we can get some of our water from eating leaves. There are plenty of survival stories where someone has lived on a half pint of water a day with the survival record of a young man living 465 days on a half pint or less. To add insult, he was adrift at sea, fully exposed to the sun and winds and collected water from the dew left on his raft during the night. Lost in the woods, you have plenty of shade to hide in and can choose to not travel

during the day, reducing your risk for dehydration from sun exposure.

If the lack of water scares you, water can be collected from plants in other ways besides eating them. If you come upon standing water, consider it toxic until you investigate it carefully. You can tell water is toxic if it smells like almond or is any color but green or clear. Also, if nothing is living in it, it's likely you won't either. Fish, bugs and mosquito larvae cannot live in polluted water nor can green algae. Thus if you see life, or algae, scum, or bright green plants, you've likely found clean water. Barring a dead animal intoxicating the water way up stream that you can't smell, it's likely free of parasites or pathogens. It's always best if you can boil water you've found but that supposes you can make fire. If the choice is dehydration, which can muddle your thinking in a few hours, then drink without boiling it. If you've found leaves though, avoid suspicious water like the plague because, well actually, it is the plague.

It could be that mosses are your only source of water. In fact, finding and holding water are the primary job of a moss and they are instrumental in creating humidity. Wring them out like the sponge that they are and carry them with you to collect moisture as you hike.

You can find water in hollowed out logs or dips in stones and you can follow animal tracks, especially ones headed downhill as animals seek water in canyons twice a day. Do not tread on the tracks and erase them - they are your map back to your starting point before you went for water. And if following tracks, make yourself noticeable and noisy - it usually doesn't fare well to scare a drinking animal, especially if they are a mother protecting their young.

You can tap into vines by cutting near the ground, making another cut 4 feet above that while being ready to capture the water as it starts to pour out quickly. Once that length has drained, recut four feet above the second cut and in this way

you can gather a quart in 24 hours. If the juice is milky or white, it is toxic *(Maxim: never eat a milky stem)*.

You can collect dew by rolling leaves up like funnels or finding long narrow leaves that you can prop up on forked sticks giving you a rain gutter effect, where you collect the dew running down into a catchment. You can also gather dew by tying your clothes around your ankles and walking among leaves and grasses. By wringing out the clothes for the free water, you are using clothing like a wick. This is best done before the sun dries out the landscape. Canes and rushes and even flower blossoms act like water vessels every morning and you can tip them out and drink from them like a cup. A dry creek bank can still have underground puddles when you dig at the outside curve of the creek. Dig down a foot or so and it will fill up with water for you to scoop out.

You can fashion leaves into containers with either leaves big enough to shape into a basin or by "glueing" them together with pine sap. The leaves that make up the roof of your shelter can be fashioned into dew collectors, working while you sleep. Think of each leaf as if it's a canteen, carrying a bit of water for you wherever you go.

You can also weave grasses or reeds into a bag, smear it with pine pitch to waterproof it and take the collected water with you as you move. As much water as you might harvest from these lifesaving tips, you still must concentrate on conservation.

If water is scarce, it's essential to keep your mouth closed and thus, avoid overexerting and breathing heavily -- we lose a lot of water through respiration (blow on a window or mirror to see how much water escapes with each breath). Called "insensible water loss" because we aren't aware of it, we can excrete 10-20% of our water through respiration and another 8% through sweat. So slow down, keep your mouth shut, and don't break a sweat. If it's a case of survival, speeding up will slow you down.

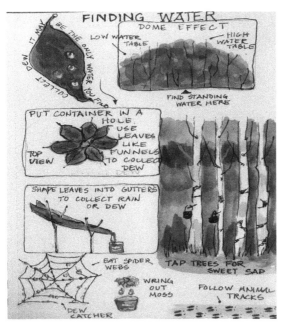

FINDING WATER

DOME EFFECT

LOW WATER TABLE — HIGH WATER TABLE

DEW IT MAY BE THE ONLY WATER YOU FIND COLLECT

FIND STANDING WATER HERE

PUT CONTAINER IN A HOLE. USE LEAVES LIKE FUNNELS TO COLLECT DEW
TOP VIEW

SHAPE LEAVES INTO GUTTERS TO COLLECT RAIN OR DEW

EAT SPIDER WEBS
TAP TREES FOR SWEET SAP
WRING OUT MOSS
FOLLOW ANIMAL TRACKS
DEW CATCHER

The other way we lose water is through tears, many of which we might shed in this dire situation we have found ourselves in. There are three types of tears, each with their own function and chemistry. Basal tears lubricate our eyes every few seconds with antioxidants. Each blink releases dopamine. Remember dopamine is a calming hormone - one we can make thoughtful decisions with and is not useful in Flight or Fight where our blink turns into a wide eyed stare. This occurs so we can keep an eye on our enemy, with the wide eyes releasing cortisol and preventing the release of dopamine.

The tears we shed from irritants are called reflex tears and occur with strong vapors/odors, vomiting, coughing, sneezing or yawning - even bright light. They serve to wash out irritants just as a cough or sneeze clear out our lungs. Emotional tears (also called psychic tears) occur with very strong emotions. When we finally break down and cry in despair, hoping to see our friends and family again, trust that these tears are a profound regulator of stress hormones. Not only are they

anti-bacterial and have a natural pain killer in their composition, they release the stress hormones of cortisol and adrenaline. These mentally confounding chemicals are literally moved out of the system through a stream of tears. Psychic tears are released with any very strong emotion so if we've made it out alive, which we will, those tears will occur again but this time with a good dose of relief mixed with pride.

Calming and pacing yourself are all important. Plan early to build shelter and arrange your water/dew collectors (if you aren't making shelter by 2 or 3 pm, you are behind schedule). Many cultures have pacing rituals that conserve energy including siesta, tea time, meridian rest periods, power naps, meditation and chanting. Those cultures practice these versions of a power nap at mid-day when we just happen to be the lowest in serotonin and dopamine, second only to our lowest levels found during sleep. None of us make good decisions from 3pm to 7 pm. It is thought that your surgery team is more reliable having stayed up all night and operating on you at 10 am than if they've had a great nights sleep and performed on you at 3 pm. Your recovery time is worse, you require more pain medication, your vitals are slow to recover and your surgery was prone to more errors. World records in the Olympics seldom if ever occur if the race or performance is between 3-7 pm. There's going to be a winner but not a world record. We just aren't at our best brain chemistry during those bewitching hours. This could even be more critical when out in the woods. Best to travel in the morning and after a rest, travel again in the evening. Chanting or singing during your trek can warn predators of your presence and serve to further calm the brain.

Vocal calming is used in medicine for laryngeal spasm disorders, dry drowning, anxiety or panic attacks, and asthma or breathing disorders. Certain chants have been found to regulate breathing in such a profound manner, there's no medical intervention that can match it. Reciting the Rosary, reciting Shakespeare, humming Beethovan, sing-songing

nursery rhymes or performing Tibetan chants all share a certain rhythm that turns out to perfectly regulate our breathing and calm the vagal nerve. If our mind and anxieties start to race, we can replace those thoughts with any song you know by memory or ideally one of the above that utilize iambic pentameter. This rhythm is why most people like Shakespeare even though there were more profound playwrights; why most people like Beethoven even though others hold more musical genius; why nursery rhymes are soothing even though the words depict pure horror for the most part; and why the Rosary or Tibetan prayers calm most everyone despite their religious leanings (or unleanings). Affirmations can help to calm the mind (remember this is goal number one - stay calm so you are fueled by your logical, problem solving hormones). One of my favorite affirmations or recitations is from the Bible (of all places as I am a devout atheist) and states "yea though I walk through the valley of death....". I like it because of the verb "walk." In other words, you're not supposed to camp out in the valley of death - keep moving. It also suggests you walk "through" not around - don't veer off track. You're strong enough to walk straight through. Moving can also mean to keep your thinking moving. Depression is having one persistent thought and in a sense, camping out with it. If you welcome anxieties and depressive thoughts in, it's a healthy thing to feel them and move on and yet another to get them their own sleeping bag while you make them s'mores. Suicidal thinking is even more dire and is the dangerous practice of making a permanent decision about a temporary problem. You walk through the valley of death - you don't stop for a picnic.

While tears release stress by moving hormones right out through your tear ducts, tears can also be "caught" for re-drinking later. In Victorian times, tear catchers were made from glass, pewter, or porcelain and had a lip at the opening that was placed under the cheek bone. As the tears flowed, the tear catcher filled. It was then placed in a notable spot, either on the mantel or in a window sill so that passerbys could see

you were in mourning. A slight bit would evaporate but would be filled again the next day, a measurement of how much you had cried. When evaporation kept a quicker pace than your efforts to refill, the most painful part of acute grief had passed. Thus, grief lifts at the pace of evaporation which is slowly but surely. If you are lost, tears can be collected and recycled. When you're thirsty, you quickly realize that every drop counts.

Boy did we digress but see, that's a good example of why you shouldn't veer from your path. Back to finding water.

It's unlikely you will chance upon a creek or river, and if you do, your problems become focused on how to carry some out with you once you leave the source. Weaving leaves and reeds together and waterproofing the inside with pine pitch will give you a canteen of sorts. Hollowing out sticks to make them straw like, closed on one end, can serve as a canteen. Spider webs, so high in lipids and protein that, ounce for ounce, they are comparable to meat, can be a source for dew and completely edible. Wringing out mosses will give you water. The entire function of mosses in a forest is to absorb and move water and they are essentially in charge of humidity by their very function. Once dry, carry them with you to collect moisture while you walk as they are light. Don't count on finding mosses along the entire trek - carry them with you just in case. Tied to your clothing, they can collect water or if there's no humidity in the air, and it is cold and brisk out, use moss as insulation that can wick sweat from your skin. This wicking effect makes them perfect for menstrual pads, wound coverings and insoles inside your shoes.

If you brought a lunch with you on what was supposed to be a day trek, let's hope something was wrapped in a plastic bag. This of course can be a canteen of sorts, used to carry water but It can also be used as a water catchment system. Wrap it around any leafy greens whether it is over the bough of a tree or a bush, gathering about 20 leaves. Tie the end tight around the branch. The leaves will respire through the night, leaving a puddle of water in your bag in the morning. Without plastic,

wrap a large leaf around a bundle of smaller leaves and secure in the same way as the plastic. It will gather water and act as a still.

If you find a puddle and fear the water is stagnant and toxic, dig a whole one foot away and one foot deep. This is called a "gypsy well." The water from the puddle or even in a dry creek bed, will filter through the dirt for that 12" and fill the hole. People often think they can drink their urine, which if fresh is indeed sterile, but the saltiness will increase your sensation of thirst, making you panic for water. If you must drink it, pee into a plastic bag or large leaf and drink the dew that evaporates on the sides. This will be more purified. And never, ever, neverever drink salt water. It leads to delusional thinking very quickly which hastens the likelihood of death. In fact, you won't even know you're dying.

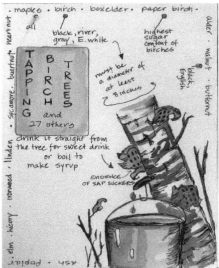

Yet another source of water is in trees themselves with about 29 varieties offering sweet, nutritious sap. You can look for telltale holes, lined up as if a holepunch has poked through the outer bark. These are made by sapsucker birds. But you can make your own hole by driving a stick just a few inches

into the outer bark, banging it with your shoe or rock. Have a stick you've prepared to be the tap by hollowing it out so it has a trough. Place your leaf containers under it and after a few hours, you'll have enough to drink. The trees must be about 18 inches in diameter to give enough drinkable sap. You can even make syrup by boiling it down to concentrate the sugar content just like maple syrup farmers do. Trees that offer drinkable sap are ash, all maples, black birch, river birch, gray birch, English white birch, paper birch, alder, black walnut, English walnut, butternut, poplar, elm, hickory, ironwood, linden, sycamore, heartnut and boxelder. You best bet if confused - if a tree is deciduous, having lost its leaves during the fall, you can likely tap it. It won't hurt to try - it's a couple of hits with your shoe so it's not like you will expend energy and hard to come by calories in being wrong. Since it takes hours to milk the sap, it's a great task if you've decided to hunker down and await rescue. If you don't know where you are and your plans of trekking out haven't paid off quickly, the likelihood of being rescued occurs when you stay as close to where you were supposed to be as possible. Sometimes, we don't walk through the valley of death, we sit down. But don't despair when you sit and wait for rescue - many a victim has curled up and died even just one or two days after being lost. They had tools, the right clothes, food, and even water but were missing something - they had no spirit to live. They just inexplicably die. That's not you. Not today. You have syrup coming. You aren't lost, you are right here waiting for syrup and rescue.

STICKS AND STONES

When we are knee deep in a crisis, we usually feel ill-equipped. Even when we get the job we worked so hard for, we often have "imposter syndrome." We think we don't have enough education, we aren't trained, we don't have the experience, and everyone is smarter than we are. But it is known that successful people are often lacking in at least one of those things and most often, all of them. What do they have

that makes them successful? They have grit - they are scrappy. It's actually suspicious if you don't have imposter syndrome. So don't worry if you brought no tools with you.

What do you do if you have no knife, no walking stick and no food containers? You'll have to make some. A long branch will make a good walking stick which can be used to test for loose gravel as you trek. It can measure how deep a stream is before you cross, and fend off animals should you be so very unlucky if one sees you. A long stick can keep you from getting injured.

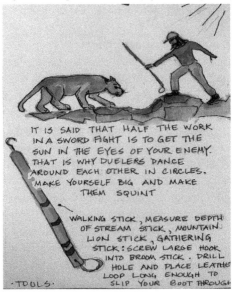

IT IS SAID THAT HALF THE WORK IN A SWORD FIGHT IS TO GET THE SUN IN THE EYES OF YOUR ENEMY. THAT IS WHY DUELERS DANCE AROUND EACH OTHER IN CIRCLES. MAKE YOURSELF BIG AND MAKE THEM SQUINT

WALKING STICK, MEASURE DEPTH OF STREAM STICK, MOUNTAIN LION STICK, GATHERING STICK: SCREW LARGE HOOK INTO BROOM STICK. DRILL HOLE AND PLACE LEATHER LOOP LONG ENOUGH TO SLIP YOUR BOOT THROUGH

·TOOLS·

It is said that half of the strategy in a sword fight and interestingly, the most important half, is in managing your environment. The first thing you need to do when confronted by an enemy, which in our case would be a bear, boar or mountain lion, is to gain higher ground and get the sun in their eyes. During a fight, our brain chemistry switches to adrenaline and cortisol, our eyes open wide to take in the largest view possible, and we shunt blood from our extremities (even our brain is an extremity) to our large deep musculature. This is no time to think, no time to bleed from scratches to our hands and

feet as we "fight and flight" and no time to blink. Blinking and squinting is what you want your opponent to do. Bright light in their eyes will give you a huge advantage. That's why dueling fencers dance about as they jockey for position, each trying to get the sun at their back and in their enemies line of vision. Better yet, if you can stand on a higher rock or uphill from them, you'll appear bigger and they will be looking squarely into the sun behind you. You'll be a blur. A large blur. Squinting releases dopamine, a brain calming chemical and hopefully that signal is enough for them to retreat instead of defend themselves.

The mountain lion has to run faster than the slowest deer; the deer has to run faster than the fastest lion. Those are all very different metabolic gambles and it's best to be at your best all day if you want to be on the right side of a confrontation. Stay hydrated, stay full and stay prepared.

One of the great ironies in being lost is that we want to remain invisible to animals but ever visible to our rescuers. We've gone hiking alone to get away from it all but our biggest fear is that we will be "not alone." Be it hoards of mosquitoes, lethal snake bites (humorously called "nope ropes"), confrontations with large animals that seem to have 50% of their body weight in claw and teeth, we realize why we live in cities in the first place -- we don't like who lives in the woods. If we become lost, we calm ourselves by thinking nothing else is lost here. The trees live here, the animals call this home and you've got to quickly make it a home away from home or die. Now you are one of them but you crave the people you left in the city. You think life back home is going along without you. In social lingo this is called "drift" -- life is not turning out as you thought. There's someplace you're supposed to be and you don't know how to get there. Or you're not where you are supposed to be in life at this stage, there's someone out there for you but you fail to find them, there's a passion or a skill you don't yet possess and all of these combine on any given day to make us feel directionless. As parents we are alarmed if our children

show carelessness as a toddler, inattention as a young child, miscalculations as a teen and preoccupation as a young adult. We wonder at their choice of friends who may lead them astray, down the wrong path, and toward their sure ruin. Then as we age, we may realize we went to school in a major we didn't love, worked jobs we hated, and stayed in relationships that didn't go forward in the right way. We're stuck in a rut and ironically think, I wasn't intuitive enough, I wasn't risky enough, I didn't feel lost enough. And thus we know that we never really found our real selves. This grief is shared by so many yet the greatest irony is this realization is that our decisions must be travelled and made alone. Very alone. If you're in the woods, this alone feeling is not just a feeling nor something as mind bending as ironic. It is the truth. You are alone. The animals might find you but that's not the company you need. You need help. You need a whistle.

An emergency whistle can be made from a willow or sycamore branch. Find a soft, greenish branch a little smaller than your wrist and about a foot long. One and half inches from one end, make an angled cut, deep enough that it is through the bark but just nicking the white inner layer. From that same end, but two inches away from that knotch, cut a ring around the entire outer bark. Do not cut into the inner meat. Remove the bark sleeve by tapping it with a rock or bigger stick all the way around to loosen it from the inner layer. Twist the bark off without crushing or breaking it. You'll need it in a minute. Enlarge the initial wedge until it is half way through the branch and add a flat plane from the wedge to the end of the branch. This is the mouth piece. Replace the bark by sliding it on to the whistle and it is ready. You can find directions and videos on how to make a whistle - often called willow flute, sallow flute, nordic folk flute or willow whistle - it's a good idea to watch someone do it before you need one. Always signal for help with groups of three -- three smoke signals, three smoke flumes, three hits against a tree with a stick and three bellows from the whistle. It is the international call for help - it is your

SOS. If you can't make a whistle, your voice can be a signal. Every hour or so, yell out in case a nearby hiker can hear you. Yell "SOS" if you are too embarrassed to shout "help."

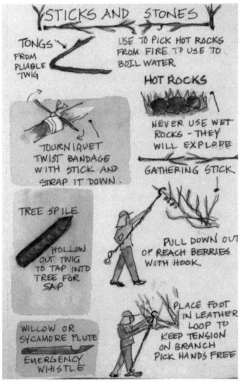

The same stick can serve as a digging tool, a carrying case and a cooking utensil. A foot long stick about the thickness of your wrist can be hollowed out leaving about 6 inches uncarved. Sharpen this end by filing it against a rock or tree to create a digging tool and use the hollowed out portion to store leaves for your meals. If you've mastered fire, stick the digging end away from the fire, angled out. Pour water into the hollowed stick and your meal will be steamed. Boil bugs as well, by placing them in hollowed out sticks with water. This stick, or several of them should be lashed to your belt loops,

gently clanging as you walk which serves as a warning so as not to surprise large animals.

Another tool in your arsenal is dirt, as in keeping yourself dirty. First, washing yourself or bathing in any way is a sure fire way to waste precious water. Second, you'll need a protective layer to retain moisture, screen out sun, insulate against wind or cold and provide a barrier from poisonous oils in plants and scratches from underbrush. Additionally, dirt can mask your scent to repel biting bugs or animals on the hunt. Rocks can be weapons, can stun a fish in a river and can be used to cook on. They can also be part of your trail blazing with messages of your direction for rescuers. You can make pigments from dirt, charcoal, berries, grasses, and leaves by mixing them with spit which has an enzyme that can act as a mordent, making a semi-permanent paint. Mark rocks with arrows telling your direction along with your initials. Rescuers, if they are out there, know who they are looking for. They know your name.

Likely the best tool you can make quickly is a spile - a small pointed stick with a hollowed out center so that it resembles a celery stock. With another pointy stick, pound a hole about 1.5 inches into the bark of a tree with a stone or your shoe. Place your spile into the hole and within minutes, you'll be draining sugar water, loaded with all the energy a tree uses for its own growth, into your container. The container can be leaves that are "glued" together with pine sap. Most trees are tappable and can provide all the fluid and even the protein, you need.

So we've come to the end of knowing what you need to know! Everything is a tool. Grasses, leaves, moss, even mud can be used to insulate between clothing layers but also are all edible. Boughs and large leaves can be strapped over your head to conserve heat like a hat. Mullein or dock can be placed inside your shoes for a blister-preventing insole, and should a blister erupt, it is perfect medicine to heal it. Remember that through all of this, you were the only thing lost: The trees weren't lost, the animals and insects weren't lost nor the plants lost. This is home to them and you learned to quickly decide

that, for right now, it's your home as well. Mitch Hedberg, the deadpanned comic has a bit about being lost. He says "If you find yourself lost in the woods, build a house and say 'well, I was lost but now I'm here.' He then grins and says to himself, "I've severely improved my predicament."

YOU ARE OUT OF THE WOODS

If you have maintained your body temperature, followed the maxims of foods to eat and avoid, and established your

internal compass, you will have found your way. With the simple rules from this handbook, you can get anyone out of a pickle, or you are reassured and have "re-remembered" how reliable a food source exists in most every landscape. We need not learn plant names, nor memorize the nutritional value (except to say how very powerful some foraged plants are) nor how to cook a foraged stew. While you once thought that survivors survive because of equipment, training, and experience, you now know that while those are good things, they are not at all decisive. In fact, relying on them can even betray you. Even knowing plant names or how to read a map and compass can lead you astray when nothing looks like it should. If you start trusting in the equipment or your skills or even your fitness, you are in for some rude surprises. Survivors rely instead on the whisper of intuition and the silent signals of the forest itself.

Once you've come out of the woods, whether from a day hike or after having been lost, you are walking out of a world into one that has become bigger because of your knowledge of it. You have a wider sense of home and a profound calm knowing

you can endure the toughest challenges. Terra incognita has become terra firma - you know what you know whether that be knowing your own strength, knowing how the natural world works and even knowing precisely what you don't know which is part of the awe and wonder of nature and your place in it. You will have lived through it having lived from it. All in all, you have been found by the things you found out. You're a survivor.

APPENDIX or THINGS YOU DON'T NEED TO KNOW BUT I BET YOU WANT TO KNOW ANYWAY

IF YOU INSIST ON FIRE (which you don't need) GOOD LUCK (you're going to need it)

You have no tools with you, no flint or a bow string, no matches or lighter. Or maybe you have them but they've become damp. What now? You have only two fire starters without tools. One is the sun and if you've waited too long into the afternoon, it won't be hot enough, or available long enough to shine a beam through glass to ignite kindling like twigs, moss or lichen. And if you don't wear glasses, you'll have no glass. Don't tell me you forgot your glasses. OK, if you did, you are left with one more source for fire - you have friction. Friction is the most difficult way to make a spark. You can cut a v-shape into a log or thick stick and rub another pointed very quickly between your hands, the point twirling against the wood. When smoke appears, blow very gently to ignite a spark with some tender. This can take hours.

If the tender doesn't take the spark, you have to find something more ignitable. That something is fatwood, the heartwood of a pine tree. Also known as fatlighter, lighter wood, rich lighter, lightered wood or lighter knot, it has resin in it which will ignite quickly. Or find a glob of pine resin, about the size of a dime, and you'll be one with fire sooner than later.

But, first you need a pine tree or conifers with oozing resin. If no conifers, you'll need different tinder. Gather dry grass, thistle or cattail down, dead pine needles or the lining of birds nests for tinder. Build a little tee-pee over the top of that tender with birch bark which is waterproof and is always dry or find little dry twigs. Strike two fist-sized glassy hard rocks. Cover your hands with your clothes/socks or with leaves to avoid the percussive and possibly electric shock from the hit. If you work hard, mixed with a good dose of luck, a spark will ignite and hopefully fall into your tender. Gently blow on the smoke to ignite a fire. The best education you can get on making fire is to make it and make it and make it. Practice at home so you know how to do it when you need it. There's no book or instruction manual that takes the place of experience in fire making and even a skilled forager/wildcrafter can take hours to ignite a fire with friction even after years of practice under controlled settings.

If you can make fire, it's most important use isn't in cooking food as that is largely completely unnecessary. And with insulation from leaves, feathers and other found materials, you won't need it to stay warm. It's best use? Make smoke signals. Smoke in sets of three will signal some fire ranger at a watch tower. Hopefully they will see your three smoke stacks spaced about 20 feet from each other so each is clearly distinct from the other, registering three separate fires. They will know where you are and that it was set by someone who is lost. But starting a forest fire is no way to get rescued so monitor each stack closely. Thus the number one reason for fire is no good reason at all.

If you have made fire and have no containers to cook in, rocks or pieces of bark can have bugs or leaves laid over them to cook. You can wrap food in layers and layers of leaves and as each skin burns off, the material inside will have cooked. Rocks picked out of the fire with a long green pliable branch bent into tongs can boil water pooled in a fallen log. All of this cooking can be a terrible waste of energy and calories not to

mention water. Best to just eat bugs and leaves raw and chew on tree bark for a carbohydrate load. All your energy should be spent on getting home - this is no time to waste resources being a gourmand.

If you can't make fire, remember that many lost souls were in environments where they couldn't make fire even if they knew how and they survived. They were adrift at sea for months (the record is 435 days alone on a raft) or stuck in a crevice after falling off an ice cliff - they survived weeks despite severe injuries and horrific exposure to heat and cold and did it without fire. This isn't the deal breaker. It's barely a game changer. I don't know why I even mentioned it.

FIRST AIDE
Lets hope you don't need it because even the experts don't know what they are doing

Plants can protect you from hypothermia just by the very fact that they provide insulation even if they don't provide calories. People who do adventure sports know that "cotton kills" - having cotton as the first layer against your skin is deadly. The cotton wicks sweat from your body but keeps it against your skin, increasing the chill factor exponentially. If you are caught in the woods without an adequate, premeditated and planned wind layer over a cotton layer, and a wool or silk layer as the first layer against the skin, you are a walking time bomb. So between you and that tee-shirt, you

have to insulate. If you can find lambs ears or mullens, something soft and cushy, you're in luck. But it's unlikely to be so lucky, so any leaf will have to do (*maxim: "three leaves, leave it be"* as it might be poison oak or ivy). Stuff your sleeves and pant legs, tying the ends off with strap like leaves or ferns, anything to prevent the loss of warmth out the openings at your wrists and ankles. The first First Aid should be to not get ill or hurt in the first place.

You can use tee-shirts and socks as tourniquets by wrapping a limb, tying a stick through the knot and twisting the knot to apply deep pressure (arteries lie deep in our limbs). Fanny packs, if you were so thoughtful to have one, can be used as neck braces with the pack braced under your chin resting on your chest and the strap around the back of the neck. A bundle of leaves fashioned in the same way might have to do. Sticks can be tied to sprained ankles to act as braces.

If you think plants couldn't possibly be powerful medicine, think again because Big Pharma knows what you don't know: a full 40% of our prescription pharmaceuticals are primarily plant based. Over the counter drugs can top that percentage easily. Most of our chemotherapeutics are plant based in their entirety. Yew, vinca, mandrake and crocus are chemotherapy cancer drugs. Velvetbean gives us L-dopa, the primary treatment for Parkinsons and most of our cardiac treatments are plant based.

Many plants and trees have salicin in them which is the active ingredient in aspirin. Chewing on the leaves or bark of white willow, black willow, pussy willow, crack willow, purple willow, and weeping willow will offer a fever reducer, pain reliever and anti-inflammatory effect. While it acts more slowly than swallowing an aspirin pill, the effects last longer. Some grasses, spirea plants and clovers offer the same relief.

Many "cures" grow next to injurious plants. It's as if every toxic plant has a pharmacy right next door. It's similar to the concept of companion planting used in home gardens - the marigold thrives under tomato plants and also is the only plant

that prevents nematodes in the roots of a tomato. Other plants use their powerful chemical to deter invaders such as the bitter caffeine in coffee plants. That same chemical, caffeine, can attract pollinators such as the light caffeine in citrus flowers. Plants grow naturally in the woods as companions to help cure you as well. They not only provide vitamins to keep you from getting infected in the first place, they are the medicine, albeit oftentimes in a diluted form, if you do.

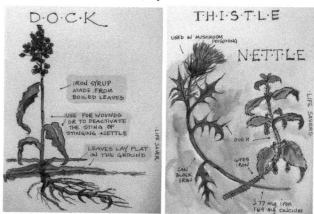

Cuisines can have their cures within their dishes. The wasabi and ginger smeared on sushi kills parasites and is shown to kill E. coli and Staph aureus. Cilantro is 2x as powerful as gentamicin in killing Salmonella if eaten with every meal, everyday. When cuisines are corrupted by eliminating parts of the recipe, say by having sushi but no wasabi or salsa without cilantro, the cures go with them. Plants are medicine.

Dock, a broad leafed plant higher in vitamin C than oranges or carrots combined, at 80% of daily needs, is usually found next to Stinging Nettle. Nettles, one of the highest sources of iron in the world (at 34% protein and 4x the amount of iron than any other plant) have thousands of irritating hairs. Wipe crushed dock on your skin for immediate relief. Dock soothes blisters or burns and the juice in the stem can be used as a protective barrier to repel the oils in poison oak/ivy. Place it in

your shoe to protect against blisters and at the same time, heal the ones you already have.

Milk thistle often grows near the poison mushroom Amanita. Used in Europe and in witchcraft cures for centuries, the U.S. didn't use it until 2017 when a Santa Cruz, California physician had 6 members of a family enter Dominican Hospital having made soup from Amanita. Gaining FDA one-time approval, he saved all but one family member. Known as the Santa Cruz Protocol, 100% IV milk thistle seed extract saved the family from death or the need for liver transplant. Eating it's seeds is critical medicine if you've eaten a poisonous plant.

Horsetail, one of the oldest plants on earth, is considered a living fossil. It can be used to scour and disinfect utensils, tools and even your skin because of the silica in the stems. It is antimicrobial, anti-bacterial, antioxidant and anti-inflammatory. Crushed, it can be used to stop bleeding, heal wounds and is used in pharmaceutical wound preparations in many hospitals. It often grows near wild berries whose thorns can prick you. Any puncture or scratch should be treated, no matter how minor it appears, as even a tear in the skin that doesn't even bleed can become infected. If plantain is the only plant you find, you are lucky because it's the only plant you need. Found in great groups in most forests, woods, gardens, behind storefronts, and even growing up through cracks in the sidewalk, it's like stumbling upon a hospital. It is an antiseptic, anti-inflammatory, as well as an astringent, antiparasitic, analeptic, antihistamine, antitumor, antiulcer, hypotensive, and anesthetic. Simply crush the leaves into a poultice and plug the wound. Need anything else? No. No you do not. And frankly, it's the only thing you have until you can seek medical help. The square stem is a dead give away to being a life-saver.

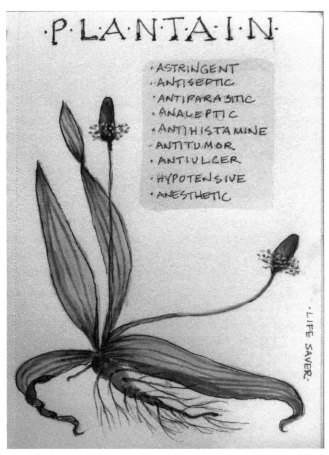

·P·L·A·N·T·A·I·N·

- ·ASTRINGENT
- ·ANTISEPTIC
- ·ANTIPARASITIC
- ·ANALEPTIC
- ·ANTIHISTAMINE
- ·ANTITUMOR
- ·ANTIULCER
- ·HYPOTENSIVE
- ·ANESTHETIC

·LIFE SAVER·

By now, you should find reassurance that something as terrifying as the disruption of the food chain is indeed a myth. The woods, our parks and even our yards provide shelter, fuel, food and water and it is all free. If you stand in your yard, the trees are edible, all grasses are edible, many ornamental flowers, roots, and leaves are edible and rainwater is collectable off your roof. Most of us have purslane and sourgrass that we pull up as weeds, not realizing that purslane is the most nutritious plant on earth and sourgrass one of the highest sources of vitamin C on earth, second only to rosehips.

Yet, we think vitamin C is in bright colored, store bought fruit or in a pill - both multi-billion dollar industries. Candy and cereal companies know this - they paint their products the bright colors of fruit, knowing our brains are always on the search for vitamin C. Since we get none from candy, our brain continues its pursuit of this hard won vitamin and goes again for the yellow, orange, and red candies. Even cheese makers know we search for vitamin C and paint their cream colored cheese orange in the case of cheddar cheese. White is uncolored and orange is colored to trick you into thinking the cows are still feeding on green grass instead of grains or hay. Cereal makers know this as well with fruit colored Lucky Charms, one of the most chemically complex foods ever designed (it's a trick to keep marshmallows soft and cereal crunchy and you are eating that trick). As with most cereals, you would find more nutrition eating the box it came in rather than the product. We throw away the food which is really the box, and eat the imposter. Food companies trust that most of us have grown completely unaware of what real food is. We have no more knowledge of the natural world than if we had landed on Mars and had to make use of it's resources. We've become aliens on our own planet. But I can assure you, Big Pharma and processed food giants know exactly what they are doing. They are making food and drugs that neither end cravings or cure you. In fact they make you overeat and become sicker just in time to use more medicine and more fake food served right to your hospital room.

WHY YOU DON"T NEED TO KNOW PLANT NAMES
(hint: because even the experts don't know)

First off, botanists know that mushrooms are neither a plant nor an animal. They aren't something in between but they do feed on dead plants and animals. They are a fungus and thus on the margin of living things. Which margin is unknown. Field guides for mushroom hunting (mushrooming, picking,

mushroom foraging, shrooming) carry a disclaimer stating that this very field guide, this one they went to all the trouble to research, illustrate, print and put in an obvious park kiosk, does not ensure your health should you eat any of the mushrooms in that field guide. Mushroom experts remind us to never eat an old mushroom (how old is old? They don't know!), nor a mushroom that bruises. Further, never eat a raw mushroom because of bacteria or bugs inside that could carry even more bacteria. Most guidebooks remind us "when in doubt, throw it out." All note that you need six identifiers to safely consume a mushroom and to check and double check the identifiers. They state you should eat a small bite of any found mushroom and wait 24 hours to test edibility even though several of the most abundant and most poisonous mushrooms take only a small bite and a few seconds to kill you.

Great field guides will admit that the presence or absence of any of the six identifiers does not guarantee edibility. For example, amanita which are responsible for 90% of the mushroom deaths in the U.S., have a distinct skirt and ring except if the rain has eliminated or "erased" the ring or skirt. They have a large unmistakable volva except it is buried and often broken off and then not visible by the hunter. That makes its distinctiveness quite indistinctive doesn't it? Their caps start as egg-shaped much like the edible puff-ball but grow into a parasol, which is a characteristic that signals danger. This parasol is tannish unless it is white. Sometimes it is red, yellow or brown. Helpful? Of course that's not helpful. It's too many

variables and even if you carved them into your memory cells so you could easily recall them in the field, the characteristics come and go. You might not forget, but they forget to remain visible.

There are two other fungi responsible for many deaths, one the False Morels and the other category called "little brown mushrooms" (LBM's). Galerinas, with 300 different species, are the most poisonous of the LBM's and with so many mushrooms in this category, it's nearly impossible for even skilled hunters to make a positive identification. Birders have the same category that stumps most expert birders. Called LGB's or LBB's, they are little gray birds and little brown birds. But back to mushrooms. The Galerinas grow on decayed wood, near tree roots or stumps except when they do not grow near decayed wood, tree stumps or roots.

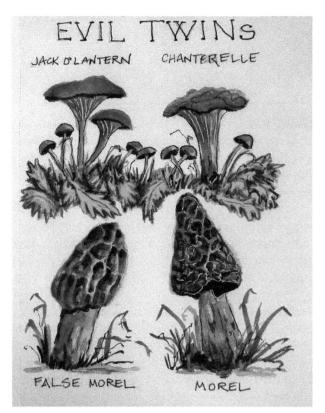

EVIL TWINS

JACK O'LANTERN CHANTERELLE

FALSE MOREL MOREL

The chanterelle can be confused with the poisonous Jack O'Lantern (JOL) except the chanterelle grows individually while JOL grows in large clusters. To compare each to the other, the chanterelle has white inner tissue when cut down the middle while JOL has orange tissue. Or white'ish orange. Or more white than orange but with a slight orange tint unless it is orange with a white tint. The JOL has gills, the chanterelle has folds. Are you with me here because it's important. Do you know a gill from a fold?

Basically remember this: never eat a bruised mushroom or one that bruises once home; never eat a slimy capped mushroom; never eat a sticky capped mushroom; never eat a mushroom with white spores after a spore test; never eat an old mushroom; never eat a raw mushroom and never eat a mushroom with a ring on the stem. Or a volva at the bottom. Nor one shaped like a parasol. Or a morel where the cap flares out rather than in. Or one with folds. And remember, all edible mushrooms are only edible for a brief time. How brief? We don't know. Many are only edible when in their juvenile stage. When does that end and their inedible adult stage start? We don't know. And never eat a mushroom with rusty spores as that might be the Galerina, known as deadly skull cap or funeral bell. It has a ring on the stem which fades quickly so then it doesn't have a ring on it's stem. It is a LBM with a parasol cap except the cap flattens out with age and loses the poisonous identifier. Oh, and one more helpful hint: Never eat a mushroom with an ammonia smell. Or one with a skirt. Or the one that has a greenish glow at night as that could be a Jack O'Lantern. And don't eat one with a red cap. Or a red stem. That should do it. Armed with these sure-fire helpful hints, you can hunt mushrooms. Except, really, after reading this, who would be that crazy?

WHEN EXPERTS NAME THINGS
(Hint: they aren't all that good at it.)

Falling under the *"never eat a flat, fan leaf base"* category as well as the maxim *"sets of three, leave it be,"* the lily family serves as an excellent example of the confounding world of

plant identification, and why you have no hope of remembering plants by name or taxonomy. There were 3,700 species in the lily family when first grouped, most with three flower petals. Taxonomists realized DNA evidence did not support the inclusion of many plants and attempts were made to split those 3700 into proper families and subfamilies. With all the experts at the ready, there were 70 different proposed splits. Eventually they were split into camas, agave, hyacinth, bunchflower, and amaryllis families and many sub-families so that finally, there are 640 noted species of Lily. That means 3100 species didn't make it into the finals! Some reference books note it is more accurate that there are only 635 species of Lily but all agree on the eventual 13 total splits that were peeled off and renamed. With taxonomists struggling with plant identification, how are we to have any confidence? To add insult, there are plants not in any of these splits nor even in the Lily family but bear the name "lily," such as the daylily (asphodela family of the genus Hemerocallis) which is edible, while plants in the true Lily family are not.

But wait, there's the Trout Lily which is in one of the splits, whose small corms are edible but the leaves are not. One must dig the corms, leaving most intact because vigorous gathering can easily kill the entire cluster and many animals rely on this food source. Just as the leaves push through the dirt and present above ground at the first sunlight of spring and under a deciduous cluster of trees, there occurs the small window of time to dig corms, about as big as half your thumb. Can you remember that? Good, because it gets a little trickier. Common names to help you identify it include Dog's Tooth Violet (but it's not in the violet family), adder tongue, fawn lily, and trout lily (both due to the mottled, red-dappled leaves). But you won't be able to identify the plant by the mottled leaves as you can only dig edible corms when the leaves have yet to unfurl. The flowers have three petals, which helps you identify the leaves and flowers as not edible (remember *"sets of three, leave it be"*). But hold on a second, there are also 3 sepals that look

exactly like the petals - same shape, same color and sitting right next to each other. Now they look like six petals and thus, possibly edible. The petals and sepals are so indistinguishable from each other, they had to have a classification all their own called "tepals." What's a gatherer to do? Remember tepals, sepals and petals? If you saw how small the corms are and that you are always on the verge of killing the entire plant (a foragers worst crime unless in a famine situation), you'd just leave this plant alone, tepals or no tepals.

And one more thing: Spanish moss is neither a moss nor from Spain. I just thought one more example might help make my point.

<div align="center">WHEN IS A BERRY NOT A BERRY
(hint: almost all the time)</div>

When it comes to berries, there's a sweet nursery rhyme to help us with edibility: "white and yellow will kill a fellow; purple and blue are good for you; red could be good, could be dead." Trouble is - that's lousy advice so forget I even got it in your head.

Another foraging maxim is to *never eat a white berry*.While some are edible, many more are deadly. The maxim should actually be extended to disallow any single formed berry, not just white berries. Once I explain the world of berry identification to you, you'll see why.

The only safe identifier is an aggregate fruit which includes blackberry, raspberry, salmonberry, thimbleberry, and boysenberry None of these are "true" berries. False berries include cranberry and blueberry, an "accessory" fruit like the strawberry and the "true" berry which is the red currant and gooseberry.

To highlight how confusing it can be even if you understand plant families, categories or identifiers, is the fact that a "true berry" in botany is a fleshy fruit without a stone produced from a single flower containing one ovary. Well that explains things. If you think that would help you identify a berry in the woods, think again even if you are an expert ovary finder. True berries

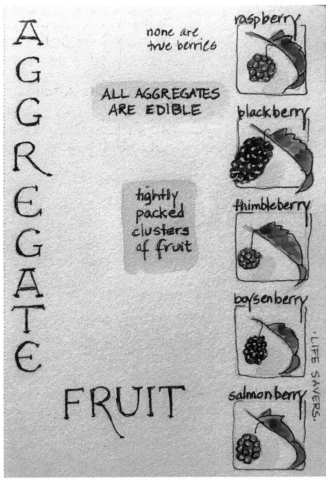

AGGREGATE

none are true berries

ALL AGGREGATES ARE EDIBLE

tightly packed clusters of fruit

FRUIT

raspberry

blackberry

thimbleberry

boysenberry

salmonberry

·LIFE SAVERS·

include grapes, currants but also include tomatoes, cucumbers, eggplants and wait for it....bananas (yes, I know, it's a berry; makes no sense) but excludes raspberries and strawberries. The fruit of a strawberry is actually the seeds. The Wild Strawberry (Frageria) is edible while the Mock Strawberry (Duchesnea) is not. They look so alike it's not even helpful to draw them one next to the other. The only distinguishing feature is a white flower or a yellowish one and

one has flat seeds while the other has slightly protruding seeds. Character features are helpful only if you can compare one to the other and usually, not even that is helpful unless both fruits are the exact ripeness, age and in full color or bloom.Taxonomy matters until it doesn't. Names are helpful until they aren't. And none of the language or the categories helps you when you're lost in the woods. You need to narrow down your choices because your first choice, to live through this, might fall apart by eating one foraged strawberry. The wrong one.

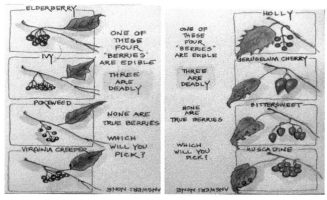

So why can't we eat a "true" berry or even a false one like a wild strawberry? Because without being an aggregate pattern, they are too easily confused with poisonous berries like jerusalem cherries, bittersweet, pokeweed, pokeberry, ivy, virginia creeper, holly, wild cherry, dogwood, or deadly nightshade. The likelihood of a yellow or green berry being edible is 10%. The likelihood of a red berry being edible is 50%. Purple and black berries are 90% reliably eaten (but if you are wrong, there are very deadly black and purple berries). *Aggregate fruits are 99.9% reliable.* So the math does all the work for you -- remember when you are lost, it is no time to gamble with your odds. Even the mulberry which looks like an aggregate, is not. It is separate fruits bundled up together and grows on a tree. If you think you've discovered a mulberry tree, how would you know if the berries are ripe because some trees

produce white berries (uh oh), some are green or even pale yellow (uh oh again). They then turn red (unripe still) to black. Unripe mulberries can be toxic and cause severe stomach upset and hallucinations - two things you cannot afford when lost. Remember you are keeping your head about you and choosing only safe fuel for your brain to work with. The plant has an identifier that gives you a clue of the potential toxicity - it's stems and leaves have a milky juice and that juice contains latex. *(Maxim: never eat a milky stem)*. Be careful of look-alikes and only eat an aggregate-looking berry if on a vine - usually with thorns. Be careful harvesting them - cuts from thorns can quickly fester. If you don't have gloves (why would you have gloves?), use plantain leaves to hold the vines - they will cushion your hands and if a thorn pokes through, they happen to also provide strong enough antiseptic to treat it.

WHY DOCTORS HAVE YOU EAT TOXIC PLANTS
(hint: because they make a lot of money)

Pharmaceutical drugs made from plant extracts, make up 40% of the prescription drugs used in medicine with hundreds of billions dollars made in the global market. They include many cancer treatment medications like vinca, mayapple, yew, mandrake, mayapple, and crocus -- all extremely poisonous if eaten unprocessed. The word "toxin" comes from the word for poison arrow, and more specifically from the poison itself which is from the word for the yew tree - Taxus.

Taxol, the most widely used chemotherapy drug, treats breast, ovarian and lung cancer. It is made entirely out of the bark of the Pacific Yew tree *(never eat a conifer with flat needles)* with six 100 year old trees needed to treat one patient - and there are about a million patients treated with Taxol each year. Bristol-Meyers makes $1.5 billion a year from Taxol and Abraxis makes another two billion using it to treat pancreatic cancer and multiple sclerosis. The strongest chemotherapy drug, Doxorubicin, is made from soil bacteria/fungus found

near the 13th century Castel del Monte in Italy. The drug carries the common name Red Devil and Red Death because of the side effects of red urine and sores on the hands and feet. Used to treat leukemia, it is another massive money maker found by gatherers of wild pharmaceuticals and used in the newest spin-off of witchcraft called Big Pharma. The important question is - how effective are these treatment?. I'm so glad you asked. They work 40% of the time. Sixty percent of the time, the experts are wrong. Do you get to be 60% wrong at your job?

How to test a plant for edibility

Why isn't this at the beginning of the book? Because I don't want you to do it. Ever. Unless you are starving to death.

If you're in a predicament and you cannot identify any plant or tree around you that's edible, you need to test a plant for tolerance. Remember it doesn't help to take a risk if there's only a few leaves on one plant -- you need a crop to eat now and stow away to eat on the long walk home.

First, make sure you have not eaten in 8 hours. If that's your status at this point in your journey, you are in a famine situation and all rules go out the window. If it's not your status, you should never abstain from eating the food you know is safe in order to test food that might not be. It's a fools endeavor. But if you must, pick a leaf and crush it. Rub it on a sensitive area of your skin like the inside of your wrist. Wait fifteen minutes and if no irritation or rash, rub it on your face, which is even more sensitive. Wait fifteen minutes and if no irritation, rub it on your lips which is near your mucous membranes - membranes carry things to the inside of your body (saliva) or repel and keep things out (tears, mucous). Wait fifteen minutes and if no irritation, hold the leaf in your mouth without chewing. Wait a few minutes and if no irritation, chew it once and spit it out. Wait another 15 minutes and chew but this time swallow a very, very tiny amount. I mean tiny. Wait 2 hours. If it is tolerated, keep eating. Such a test can take over 10 hours to

conduct so start planning for famine eating early in the day. By the time you are really hungry, you won't have the patience, nor likely the mentation, to make sure the plant is safe. You can see the near impossibility of this saving your life for days and days. The most important thing to remember is "when in doubt, don't". Don't test plants while lost - this is no time for a science experiment.

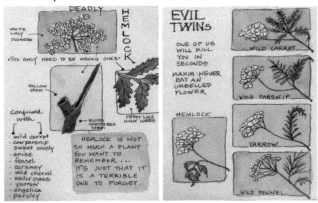

Plants are the most toxic things on earth, some killing you in seconds. Why are they more toxic than a poisonous spider or snake? Plants can't run. Being toxic is their only defense. They can't "flight" so they have to "fight."

TYPES OF PATHS

Why are the descriptors of paths last? Well, because you're not supposed to leave the path in the first place. You are supposed to stay on signed paths so you don't trample sensitive habitats, so you allow animals to live without interruption and so you don't get lost. Paths are choices people have made and more importantly, the paths experts have made for you to enjoy. Once many people copy the same decision over and over, a new path is set.. Yet, in the science of pathing (I made that up), it only takes 15 repetitions to condense grasses and soil enough to establish a path. It's a condensed version of that initial decision someone made and a combined wisdom or often, folly, that holds the promise that

there is somewhere worth going. Walking on other's footsteps is the same thing we seek when we talk to people about their career paths, the financial risks they took as they mapped their future, the query "would you do it again if you could do it over?" Then there's the story that never gets old, when we ask a couple "how did you two meet?" We are asking where their paths crossed; what diverted them toward each other; how many times their paths converged before they got together; and who wanted the other one first, as if you are saying "did one of you see a future path together and the other one straggled behind?" Most of us wonder at paths not taken and it's likely a predominate thought when lost in the woods to pledge to take a different path in life if you get out of this alive.

When rescuers are searching for "the lost" they look at lost behavior and the choices certain groups make. A very young child will curl up and sleep until found. An older child will "hug a tree," and is often found standing at a large rock or tree as if it is an authority figure. Hunters and fishermen go off trail tracking an animal or seeking the perfect spot to fish while birders, shroomers, and foragers get disoriented by looking up or down, realizing too late they have separated from the path. Rescuers then think like the group they are looking for - either following animal tracks or creeks to find hunters or asking themselves "where's the best mushrooms or berries" and "where would I go if I were thirsty."

There are names for paths with one newly named as I was writing this book - the Smile Path. Witnessed enough times by master navigator Tristan Gooley, the The Royal Institute of Navigation announced in July 2020 the formal naming of the Smile Path. Why now when he'd been seeing them for years as they veer briefly off from the beaten path only to hook right back on a few feet later? Well, prior to social distancing tactics, the smile path was seasonal and temporary. They were a diversion around crowds of people on popular paths that would evaporate and regrow after the summer throngs, or a temporary curve around a fallen boulder or tree limb that would

be cleared from the path during maintenance. It was the wide berth one would make to avoid overhanging branches only to be swallowed back up into the tree or vine, making your decision invisible and unnecessary in a week. But now the paths can be seen nearly everywhere there is foot traffic, as people step aside or go around in order to keep the required six feet of social distancing during a pandemic. With all of us wearing masks that cover our mouths, the Smile Path is our social version of an actual smile, a gesture toward protecting each other but a gesture taken by our feet.

The opposite of the Smile Path is the Desire Path. These are seen in cities as well as woods as people cut corners as they veer away from a sidewalk and take a shortcut across a lawn or a college quad. At the end of the Desire Path is what they desire, whether it be the bus stop, a quicker route to the library or in the woods, a great view, a photo op a good place for a picnic. Social Trails lead to bathrooms, water sources, well worn sites to view a waterfall or a sentinel feature like the largest tree. These trails are signed, marking the feature and in a sense, authorizing your leaving the main path. People don't get lost taking Social Trails. They certainly don't get lost on Smile Paths as they are only a slight and very brief curve away from the main path. They do get lost on Desire Paths. Sounds like life doesn't it? I lost my way thinking I wanted this or that only to find I was on the right track all along. Sounds very much like a midlife crisis.

Desire Paths are an attraction. In legal terms it would be called an attractive nuisance much like a trampoline in an unfenced front yard - you can't be held "not liable" for an injury when everyone passing the darn thing wants to jump on it. Desire implies that this path is the ones humans prefer, not ones that have been created for them. As people who follow behind see the grass trampled down, this newly forming path takes on an attraction effect and becomes a record of collective disobedience. As Gooley notes, it's people "voting with their feet." It's the question parents ask their children,

fearful they will be attracted to danger when they ask "if they all jumped off a cliff, would you jump off the cliff?" It's our fear as parents that our children won't think for themselves, won't remember what we thought were bone chilling admonitions of danger, and won't recall the poor outcomes of those who took that path whether it be overdoing drugs, not completing school and for the adults in our lives, hoping they realize that cheating at work, cheating at school, and cheating during a relationship is never, ever a good path. How is the desire path so....well...so darn desirable? Because it's a shortcut. Shortcuts get us to our outcome faster. A Desire Path gets us to something desirable. The Smile Path lets us go around something undesirable. Desire Paths is the deadly sin of paths - it is the lust for the easy way, the short cut, the cut in the road that says "you aren't the boss of me." Trouble is, many then veer off the Desire Path which is the most common error a hiker makes. When they realize they are lost, they also realize their return back to the path home is fast receding. When you take the Desire Path, you haven't behaved in a rationale way - rescuers can't magically think of where you veered off if you haven't left a trail of your own. Cheaters don't tell people ahead of time they are failing a class, leaving no time for a tutor. Affair partners don't mention they are veering from the main relationship in time to fix it or exit with grace by telling their partner the want to go a different way. Business leaders and politicians don't know how to have power and obey the rules at the same time. They can only "win" if they cheat, pollute, lie, and bully. They look like they are going down one path but in reality, they are taking roads less travelled - well, at least less documented. All in all, we're supposed to tell people where we are going and if our direction veers, tell them that too. And when you think about becoming lost in the woods, veering off a path without taking stock of which direction you are going or failing to mark your way so you can get back, you've actually not even told yourself where you are going. That's the only way you can truly get lost. You'll notice in life that when you've

gone down the wrong path, you don't even recognize yourself. It reminds me of a line in a country western song that pleads, "if you leave me, will you take me with you?" When you become lost in the woods, you didn't take you with you.

While most hikers get lost veering off a Desire Path, there are other perilous paths. The "game path" (called "herd", "pig", "elephant, or "goat" path depending on the areas' grazing animals) is a consequence of hoofs eroding the dirt. They are an animals version of a Desire Path -- it's leading them to something they want whether it be a particular food, a source of water or their home. What's important to remember is that it isn't leading to something you want unless you want to surprise an animal in their den. Animals always defend their homes. For instance, fire ants aren't particularly meaner than other ants. It's just that their ant hill is above ground rather than below. If you distrubed below ant "farms," you'd be attacked as fiercely as fire ants. They have a mightier sting because they have the flood-avoiding instinct to build above ground so as a consequence, they are charged to have more defenses. Animals protect their territory. You can't handle it when your neighbor parks in front of your house and you don't even own the street - so think of a bear seeing you park in front of their house unannounced. These are "use trails" but most often, not for you to use. Unless you hear water trickling in a creek. Finding water is golden. Then use the trail but make noise so you don't surprise anyone.

Which brings us to another trail, this one dangerous as well. In the past it was known as a "Bootleg Trail" made by illegal encampments housing stills. Johnny Appleseed became famous not because he feed the poor with apples like some fruit bearing Robin Hood, he had apple seeds that made hard cider. Today, our hard cider trees are called Liquor Stores but we still have a version of the Bootleg Trail, many in our National Forests. They are pot or "grow farms," with the trail heads boobytrapped and the growers at the other end heavily armed. As you are hiking, avoid trails that seem marked with

piles of rocks leading to a south facing clearing especially if you note pipes or drip irrigation lines. Be quiet and turn around. This is no time to make new friends nor ask them for help. They could make sure you are never found.

Paths used to be marked by plants themselves. Any seeds that attach to clothing, fur, or machinery led the way for travellers when they reseeded. The plantain bears a common name, cart-track plant in S. Africa as it lined well-worn paths. El Camino Real, the original path linking 21 California missions, still shows the mustard plant map along the now uber-paved freeway system. The mustard led missionaries between the 30 mile gaps between each mission, a days' horseback ride. A few of the missions still have the massive matilija poppy marking "one mile to go." Plantain is also called "whiteman's footstep" with its broad leaves looking both like the plantar surface of the foot and the sign that the path had been travelled by man, following him wherever he went. Dandelions also provide such a marker and can be used to get back to a trail. Not only can plantain and dandelion provide lunch along the way, they can lead you home.

While people love to believe they align with Robert Frosts' poem noting "I took the road less traveled…" few people lead a unique life path under the best of circumstances and believe me, when you are lost, always take the road most travelled. Those people knew the way home.

BIBLIOGRAPHY

A few key books were essential in the writing of this guide. Every survival and forging book informed me and a deep dive into their tips and strategies allowed me to winnow it down to the essentials. But, I wanted to write a book that showed any of us can survive when we have nothing.

Euell Gibbons: Stalking the wild asparagus
Laurence Gonzales: Deep Survival
Tristan Gooley: The Natural Navigator

94

AUTHOR'S BIO

Joy Colangelo considers herself a lostologist because no matter what she does, it always turns into a study about being lost. Her degrees in philosophy and politics of ancient Greece taught her that the loss of virtue is worse than death itself. As an athlete in her twenties, sports psychologists told her that local champions wanted to win but internationally competitive athletes didn't want to lose. In thirty years as a rehabilitation specialist, she learned that it didn't matter how much someone lost, it mattered who had lost it. Often those who lost the most function found the best in themselves through sheer will and those with lesser injuries and disabilities gave up without trying. Both as an artist and mother, she thought she was making something out of nothing. She soon realized that both creativity and children find themselves by way of their own maps that she knew little about. She is the author of *Embodied Wisdom: What our anatomy can teach us about the art of living*. She loses herself as a fabric artist, nature journalist and forager, often making her own pigments. She lives near Asilomar State Beach in California and all the watercolors and fabric collages in these pages are her own.

CPSIA information can be obtained
at www.ICGtesting.com
Printed in the USA
BVHW020300141120
593345BV00040B/1264